MW01040085

Get the eBooks FREE!
(PDF, ePub, Kindle, and liveBook all included)

We believe that once you buy a book from us, you should be able to read it in any format we have available. To get electronic versions of this book at no additional cost to you, purchase and then register this book at the Manning website.

Go to https://www.manning.com/freebook and follow the instructions to complete your pBook registration.

That's it!
Thanks from Manning!

generative
art

generative art

a practical guide
using processing

art

matt pearson

MANNING

shelter island

For online information and ordering of this and other Manning books, please visit www.manning.com. The publisher offers discounts on this book when ordered in quantity.
For more information, please contact

Special Sales Department
Manning Publications Co.
20 Baldwin Road
PO Box 261
Shelter Island, NY 11964
Email: orders@manning.com

Manning Publications Co.
20 Baldwin Road
PO Box 261
Shelter Island, NY 11964

Development editor: Jeff Bleiel
Copyeditor: Tiffany Taylor
Designer and Typesetter: Irene Korol Scala
Cover design: Irene Korol Scala
Cover image: Matt Pearson

ISBN: 9781935182627
Printed in the United States of America

dedicated to my boys, Rudy and Oz

table of contents

Part 1 Creative Coding

list of artworks

foreword

The last decade has seen a significant shift in our understanding of digital tools. Not only do we now take them for granted, we are becoming the cyborg creatures much-prophesied in 1990s millennial theory but without the neural implants and virtual reality that so alienated mainstream audiences.

Instead, we put smartphones in our pockets and walk out into the world armed with search engines, Wikipedia, social networking services, and advanced mapping services. Without giving it much thought, we have turned into augmented beings existing in a world that is simultaneously real and virtual.

This revolution would be impossible without a new understanding of software as cultural artifact. Where we once saw text processors as literal typewriter replacements, we now download and exchange apps as a popular pastime. Websites that used to be closed domains of proprietary information now sport public APIs, enabling professionals and enthusiasts alike to create ever-popular "mashups" based on their data.

In the creative field, the most significant development is the realization that software processes aren't simply tools, but can become the very material from which works are made. New design disciplines like interaction design and information visualization are based on the application of computational solutions to design problems, while generative art has become a household term describing artworks articulated as code. A new generation of electronic artists has turned to code as fertile ground for conceptual and formal experimentation, simultaneously providing a pragmatic framework for computational creativity and a theoretical context for the created artwork.

The roots of this trend can be traced back to the mid-1990s, when creatives began experimenting with HTML, Shockwave, Flash, and Java applets as a creative medium. Predating iPhone and Android by more than a decade, the World Wide Web was the first media platform to deliver computational content, authored using tools aimed at creatives rather than computer scientists. But despite the important work done in this "golden age" of the web, the real revolution came with the introduction of open source tools such as *Processing*.[1]

Written by artists for artists and initially intended as teaching tool, Processing is a simplified language built on top of Java, focusing on creative applications like real-time graphics and interactive systems. It eliminates tedious tasks typical to regular programming tools, allowing even novices to get sketching with code quickly. But despite its simplicity, Processing is a powerful

1. Processing is just one of many free development tools intended for artists. Pure Data (PD) and vvvv are both so-called visual patching tools, popular for video and sound manipulation. NodeBox and Scriptographer are specialized for graphic programming, and systems like Structure Synth and Context Free are based on recursive shape grammars.

platform capable of supporting the most demanding digital media application. It's designed to be extended through user-contributed libraries that add functionality to the core framework, and is easily integrated with other systems like the popular Arduino microcontroller. A recent development lets users develop apps for Google's Android OS, making Processing a veritable Swiss Army knife for creative computational.

Although generative art has grown in popularity, it remains somewhat mystical as a practice, the domain of vaguely mathematical magic. How are these works created? How do we sketch in code? The technical aspects of writing code are tricky enough, let alone manipulating algorithms into serving aesthetic principles.

Visual thinkers think in terms of logically connected workflows: take a photo, manipulate it, combine it with graphic elements, add typography. Coding often involves obscure steps that at first might seem completely disconnected from the aim of producing a visual composition: find a dataset, write a parser, analyze boundary values, write an algorithm for visual translation, tweak the parameters, and rewrite. Code requires identifying logical connections between elements and describing behaviors in terms of rules that might seem unrelated, and beginners tend to find it frustrating when the need for trigonometry invades even the simplest animation.

Fortunately, most of the essential tools in the generative artist's repertoire can be described as a set of simple principles. As Matt Pearson writes, generative art is easy—at least, sometimes. Using Processing as his tool of choice, Matt shows how to progress from primitive drawing to more complex topics like interactive animation and simulated phenomena such as cellular automata. But rather than just demonstrating syntax, he describes the creative process involved in designing generative systems, showing how manipulating parameters and tweaking algorithms can result in radically different outcomes.

Having grown up with the ZX Spectrum and worked many years as a programmer while also being involved in the arts, Matt is perfectly placed at the intersection of code and creative thinking. In this book, he sets out to provide the reader with a toolbox of recommended practices while simultaneously introducing a deeper cultural context to the work. It should have readers quickly thinking beyond simple code tricks to the more complex ideas that underlie a computational model of form. My personal favorites are the sections on "wrong" ways to do things, showing how a simple form like a line or a circle can be transformed into complex systems by thinking creatively about the way they're constructed.

Happy coding!

Marius Watz

Marius Watz is an artist working with code as his material, who has shown his work around the world. He is the founder of the Generator.x platform for generative art and design and is a lecturer in interaction design at the Oslo School of Architecture and Design. He is currently based in Oslo and New York.
http://mariuswatz.com/

preface

I'm going to issue a disclaimer before we proceed: I tried doing it the right way, I tried becoming a "real" programmer, I really did. But I failed. I started a computer science degree, but dropped out after about a year and a half. I'm sorry, but it bored me senseless.

As a young man, this career shift wasn't entirely motivated by a need to restore the right-left hemisphere balance to my young brain; it may also have had something to do with the worry that knowing a lot about Alan Turing and C++ was probably not the best way to get a girlfriend.

My studies of early 1990s ideas of computing had so repulsed me that I made efforts to stay as far away from computers as I could for the next 10 years. For much of the 90s, I didn't even own a computer; instead I had a guitar, an attitude, and an ill-advised haircut. I was only drawn back toward the end of the decade when the web started to take off, and a lot of creative people suddenly discovered that what they'd been doing recently with video cameras, photography, and hypertext was now being called *New Media*, and *everyone* was doing it. This rehabilitation of computing has continued unabated, to the point that today, to say you "work with computers" is about as meaningful as saying you breathe air.

At the time I dropped out, I couldn't imagine anything worse than spending the rest of my days communing with these soulless beasts of logic and wires. But in adulthood, I discovered a new enthusiasm for computing after stumbling across a simple realization; that *computers* and *computing* were not the same thing. What hadn't been made apparent to me during my university days was that computation is everywhere, and it can be a thing of beauty.

Computing is what a stream does as it finds its way downhill toward the ocean. It's what the planets do as they move in their orbits. It's what our bodies do as they maintain the balance needed to keep us upright. It's what our DNA does as it unravels. Computing is what I'm doing now as I process these ideas and output them as text—and what your brain is doing as you read the words and form your own ideas as a result.

This is why I can say, without contradiction, that while I still find computers boring, I think computing is cool. The only place computers really come into it is in attempting to *simulate* these computations or creating new ones to rival those of the natural world. Which brings me to the subject in hand: generative art.

As a jobbing coder, I always dabbled with generative ideas when I could. Whenever I got my hands on a new bit of kit, the first thing I'd run would be a few fractal creations to test its limits. But I'd never taken it seriously as an art form, and I was only dimly aware of the growing movement of artists who did. But this side of the millennium, that movement was gathering pace and becoming more visible, as the tools also became increasingly powerful and accessible.

I've always believed that if you want to do something, the best way to go about it is to stop talking yourself out of it and just get on with it. Nothing should stop you, as long as you're happy to work without reward. Although, as experience testifies, I've found that if you do something long enough and maintain an enthusiasm for it, sooner or later someone will end up offering you money for it. Or ask you to write a book about it. Admittedly, this principle may not apply to self-abuse or serial killing, but it's certainly true of most artistic endeavors.

So, you could say the genesis of the book you're now holding (physically or virtually) was in a project I started, in accordance with this principle, in 2008. I decided that if I was going to take generative art seriously, I'd start a generative art blog. I called it *100 Abandoned Artworks* and set myself the task of producing a generative artwork every week, throwing it out there in whatever state I had got it to (hence the *abandoned*) before real-life commitments intruded on my playtime. I included the source code, Creative Commons licensed, so anyone could take my abandoned, half-finished works and find some use in them. I pledged that I wouldn't allow myself to stop until I reached 100. This strict, self-imposed schedule was a conscious way to force myself to reorder my priorities. I knew that somehow I found time to spend hours reading comic books and watching no end of god-awful movies, yet generative art, something I enjoyed, was the thing I never found the time for.

The discipline worked. Not only did I find the schedule easy to maintain, my enthusiasm for Processing (the tool I had chosen) keep growing. The project took me on many diversions, into print and video, and started feeding back into my day job. It was somewhere around the 50 mark that Christina Rudloff at Manning got in touch to discuss the possibility of a book.

That project is now complete, as is the book. This book is a snapshot of where I am right now, of everything I've learned and unlearned in my programming career up to this point. I didn't want to write yet another Processing book—I don't particularly like programming books, and I've never read one from cover to cover. I wanted to write something more inspiring, something that was about the *why* as much as the *how*. Programming art is a different discipline than programming systems, and there should be no right or wrong way to use the powerful tools we have at our disposal. I wanted to get across how coding can be liberating and creative, not just structured and orderly, and accessible to more people than just the techies. Whether I've succeeded in this aim is for you to decide.

acknowledgments

Huge thanks go out to all the following, for the work they contributed, for making it possible, for being nice, for supporting the project, for putting up with my crap, for reviewing the manuscript, for giving feedback, and/or just saying the right thing at the right time:

Alan Sutcliffe, Rob "SanchoTheFat" O'Rourke, Justin "Soulwire" Windle, Seb Lee Delisle, J4mie Matthews, Ron Wheedon, Robert Hodgin, Aaron Koblin, Jeremy Thorp, Jared Tarbell, Casey Reas, Ben Fry, Manfred Mohr, Reza Ali, Jerome "01010101" Saint-Clair, Dan Shiffman, Shardcore, Norman Klein, Kerry Mitchell, Orhan Alkan, Patrick Steger, Andy Dingley; at Manning: Marjan Bace, Emily Macel, Christina Rudloff, Jeff Bleiel, Mary Piergies, Tiffany Taylor, Barbara Mirecki, Irene Korol Scala, (and anyone else who had the misfortune of dealing with me); also Philip Galanter, Kevin "lomokev" Meredith, Marc Banks, Alice Eldridge, Rich "Text Format" Willis, Rifa Bhunnoo, Chris TT, Ewan Swain, Eric Bates, Iestyn Lloyd, Alec Morrison, everyone at dotBrighton, Ruth and Jo, plus my friends at FutureDeluxe and TGSi (in part for letting me leech desk space while I was writing).

Special thanks to Marius Watz, for his artworks and foreword; Frederik "w:blut" Vanhoutte for his artworks and technical review; and Cliff Pickford for the Alan Watts quote.

Apologies to anyone I've forgotten.

Most of all, thanks to my patient wife, Deborah, who somehow still loves me, despite my being a massive nerd.

about this book

Within these pages, you'll learn how to begin experimenting with generative art. We'll explore tools and algorithms and creative approaches, and look at ways you can take ideas and develop them further. But there is one thing you won't learn from this book, and that is how to be an "artist."

If this book were to be just a collection of recipes for you to follow, to produce certain aesthetically pleasing results, it would be missing the point—not to mention hugely arrogant. The appreciation of art is entirely subjective, so if I were to declare that there is a right way to go about creating art, I would be in need of a slap.

Similarly, this isn't a book about "design." With design, the intention is to produce a visual that produces the same response in everyone who sees it—the intention (such as "street," "retro," or "subtle") should be mostly unambiguous. With art, you're still aiming to produce a response, but if that response is different in different people that doesn't matter. It's fine for one person to like a piece while another sneers. Even better, if one viewer *loves* the work, we would hope another might hate it. If we can foster such an extremity of reaction, it'd be a measure of success. Perhaps the only cardinal sin of art is to be boring.

This book is peppered throughout with stills from my own generative works, most of them relating to whatever topic is under discussion, but others are just randomly thrown in as a breather. Source code for many of these images can be downloaded from http://abandonedart.org and from the publisher's website at www.manning.com/GenerativeArt. It is also published under a Creative Commons license, so you're welcome to take these works and deconstruct them, adapt them, mash them up, and destroy them. But, importantly, you're also entitled to think they're rubbish. It wouldn't bother me too much if you did—that isn't the purpose of the book.

I would hope that even if you hated every single piece of artwork within these pages, you may still get something from the book, if only the inspiration to do something better. In this way, even bad art can be good, as it is only the very worst that can inspire an extreme reaction. To not produce any reaction at all is to fail as an artist.

If there is one thing I want to get across with this book, it's a *style* of programming rather than a rulebook for achieving certain types of results. I want to explore how programmers can open themselves to more artistic flurries, a way of freeing the brain to get creative with code.

The roadmap for this approach is as follows: The first part of the book, "Creative Coding," sets the scene and teaches all the necessary prerequisites. Chapter 1 looks at the concept of generative art from a few different angles; then, in chapter 2, we get up to speed with Processing, a simple programming language that will be our main tool for the rest of the book.

Part 2, "Randomness and Noise," begins to break down my process for creating generative visuals with Processing, looking at the algorithmic creation of the simplest of forms, and considering new ways of approaching them. We begin with the drawing of a line in chapter 3; we see how even this can be spun out into interesting spaces with a more fluid approach, extending the idea to trigonometry with chapter 4. Chapter 5 explores animation and 3D drawing.

The final part of the book, "Complexity," goes beyond the machine and looks at three organic processes taught to us by the natural world: emergence, autonomy, and fractals. We maintain a practical approach throughout though, exploring how we might simulate these phenomena in code, and learning, by stealth methods, more advanced object-oriented programming required for these experiments.

There is no right or wrong way to be a generative artist. There are no rules or recipes. Generative art is about the organic, the emergent, the beautiful, the imprecise, and the unexpected. It's about exploring these within a world of logic and precise mechanics. This delightful paradoxicality makes it an almost Zen approach to computing: playful and organic, free of restraint, and inviting a natural flow.

To put it more simply, generative art is about having fun with coding. Programming isn't just about good practice, structure, and efficiency; it can be about freedom, creativity, and expression, too. The programming language can be an artistic tool, capable of making both profound statements and banal ones, if in the right hands.

about the author

Matt Pearson is a creative coder and sometime writer. A perpetual freelancer, he has donned his coding gloves for clients such as London's National Portrait Gallery, the Cleveland Museum of Art, Perth Arts Festival, the BBC, the Victoria and Albert Museum, London, The Art Institute of Chicago, the Vancouver Museum of Anthropology, Paramount Pictures, and the UK government. He lives in Brighton UK, where he shares a house with a number of small blonde children, a collection of MacBooks, and probably the most beautiful woman Wolverhampton ever produced. You can find more of his incessant babbling at http://zenbullets.com.

Author Online

You can also contact Matt through the Author Online forum run by Manning Publications at www.manning.com/GenerativeArt. Manning's commitment to our readers is to provide a venue where a meaningful dialogue between individual readers and between readers and the author can take place. It isn't a commitment to any specific amount of participation on the part of the author, whose contributions to the book's forum remain voluntary (and unpaid). The Author Online forum and the archives of previous discussions will be accessible from the publisher's website as long as the book is in print.

introduction: the organic vs. the mechanical

> " From the standpoint of Taoist philosophy natural forms are not made but grown, and there is a radical difference between the organic and the mechanical.
>
> Things which are made, such as houses, furniture, and machines, are an assemblage of parts put together, or shaped, like sculpture, from the outside inwards.
>
> But things which grow shape themselves from within outwards—they are not assemblages of originally distinct parts; they partition themselves, elaborating their own structure from the whole to the parts, from the simple to the complex. "

Alan Watts, 1958

Alan Watts (1915–73), English philosopher and Zen monk, was a Buddhist in a very 1960s sense. He was a master of theology, a priest, and the author of more than 20 books on Zen philosophy. He also experimented with psychedelic drugs, both on a personal level and in laboratory trials. He had plenty to say on the subject of creativity and technology but never, as far as I know, said anything specifically on the subject of generative art.

In the above quote, he's talking about the incongruity between the natural world and the manmade, separating creation into the organic and the mechanical. This concept of organic growth, whereby forms are constructed "from within outwards" describes this book's topic rather well; but in such a clear bilateralism, how can we say that a work of computer programming belongs to the world of the organic rather than the mechanical?

Generative art is neither programming nor art, in their conventional sense. It's both and neither of these things. Programming is an interface between man and machine; it's a clean, logical discipline, with clearly defined aims. Art is an emotional subject, highly subjective and defying definition. Generative art is the meeting place between the two; it's the discipline of taking strict, cold, logical processes and subverting them into creating illogical, unpredictable, and expressive results.

Generative art isn't something we build, with plans, materials, and tools. It's grown, much like a flower or a tree is grown; but its seeds are logic and electronics rather than soil and water. It's an emergent property of the simplest of processes: logical decisions and mathematics. Generative art is about creating the organic using the mechanical.

Watts' opposing categories of worldly things, the mechanical and the organic, are easy to separate. A building has straight edges and sharp corners: it's functional and accurate; it's in the realm of the mechanical. A tree is irregular and temporally inconstant, its leaves shake in the wind and shed in the autumn; it's in the realm of the organic. Mechanical things are constructed; they're fashioned, as Watts says, from the outside in. They're built, drawn, assembled, sculpted, manufactured. On the other hand, organic things are grown: they're self-structuring, holistic. Their forms come about without intent; they don't conform to designs or blueprints.

Like the landscape gardener, the lot of the generative artist is to take naturally evolving phenomena and to fashion them into something aesthetically pleasing. It's finding that point of balance between the beautiful unruliness of the natural world and the desired order of our ape brains. A garden that is unkempt and overgrown is unpleasing to us because it's too far into the realm of the chaotic, whereas concreting the area instead is the tidiest, most ordered of solutions, which also removes all beauty.

The sweet spot is between the two, where the grass is neat and evenly cut but still no two blades are alike or move in perfect synchronicity—where the colors of the flowers are evenly balanced, but not in a way that is exact and precise. The sweet spot is where the "art" lives.

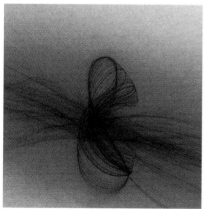 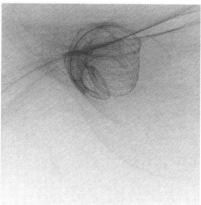

Figures i.1, i.2, and i.3

Opiamas Trangelo (2010) by Matt Pearson. Multiple artworks produced by a single algorithm.

From here on, if the artist is unspecified, assume that the artworks are by the author.

You may be used to skimming figure captions for clues as to how the figure relates to the chapter. But sometimes a figure is just there because it's prettier to look at than unbroken text. Sorry.

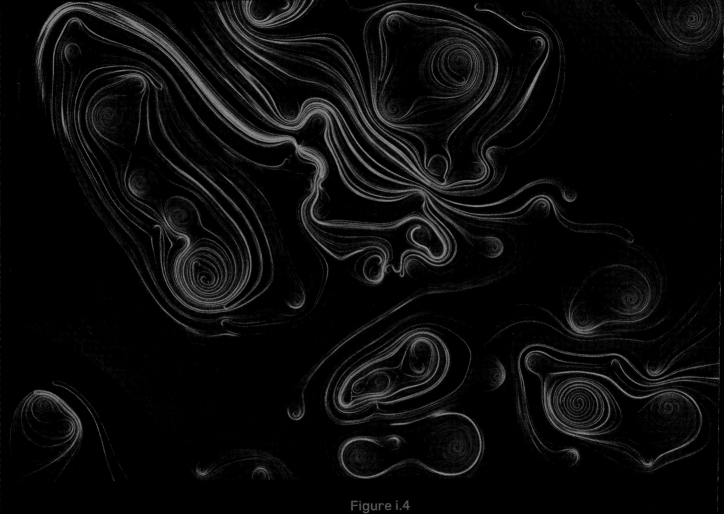

Figure i.4

Addition/Subtraction, Variant (2010) by Robert Hodgin, an artist whose work continues to be a huge inspiration.
See also figures i.5 and i.6.

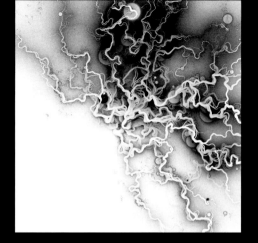

Figure i.5

Magnetic Ink by Robert Hodgin (2007). This work was created using a flocking algorithm, each agent leaving a mist of
See www.flight404.com/blog/?p=86 for further explanation. You'll learn more about flocking in chapter 6.

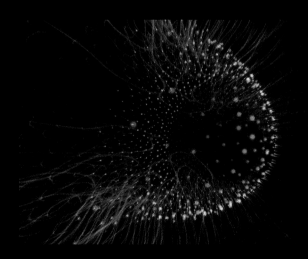

Figure i.6

Jelly (Magnetosphere) by Robert Hodgin (2007) . Most of Robert's early work, including this image, was created
using Processing, a tool you'll be learning a lot about.

Generative art is easy

If you were to decide to become an artist, you would need to take only one step: write your name, write "(artist)" after it, and then print it on a business card. Congratulations: you're an artist. From this point on, every scribble, gesture, utterance, or movement you make can be defined as art, if you so choose. Every stool you leave in the cistern of life can find meaning to someone, somewhere, even if it's only yourself. You may not be a particularly *good* artist, but an artist is what you are.

Becoming a "generative artist" is a little more specific, but not that much more difficult. You may infer that some kind of skill set is required to qualify for this title. Perhaps you see learning a programming language as a significant barrier to entry. This isn't the case; the language isn't a barrier, it's a shortcut. Compared with other disciplines of the arts, where a minimum skill level is necessary for your work be taken seriously, with generative art most of the skill doesn't have to be learned; it's already encapsulated within the tools.

It takes many *years* to learn to paint, to draw, or to sculpt, but the programming aptitude required to get professional results in generative art can be learned in a matter of days. And if you don't believe me, I hope this book will prove it. The images in figure i.7 were generated in only 24 lines of code, which you can view in the listing on the next page. Every time it runs, it produces a different still image.

All this code does is iterate through a grid using two loops; then, a function call on line 14 draws a circle at each grid point and displaces it in 3D space using a mathematical variance. Don't worry if you don't understand the code, or indeed the previous sentence, at this point: that's what this book is for. We'll unpack all these concepts in the first few chapters.

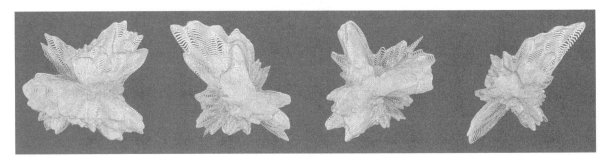

Figure i.7

Four generative works created by the 24 lines of code in listing i.1

Listing i.1 **A generative system in 24 lines of code**

```
void setup() {
  size(2000, 2000, P3D);
  background(150);
  stroke(0, 50);
  fill(255, 200);
  float xstart = random(10);
  float ynoise = random(10);
  translate(width/2, height/2, 0);
  for (float y = -(height/8); y <= (height/8); y+=3) {
    ynoise += 0.02;
    float xnoise = xstart;
    for (float x = -(width/8); x <= (width/8); x+=3) {
      xnoise += 0.02;
      drawPoint(x, y, noise(xnoise, ynoise));
    }
  }
}

void drawPoint(float x, float y, float noiseFactor) {
  pushMatrix();
  translate(x * noiseFactor * 4, y * noiseFactor * 4, -y);
  float edgeSize = noiseFactor * 26;
  ellipse(0, 0, edgeSize, edgeSize);
  popMatrix();
}
```

Even if you've never coded before, by the end of chapter 2 you'll have a powerful programming language under your belt. Then, from chapter 3 onward, you'll learn a number of techniques that will enable you to quickly achieve generative art proficiency. Taking this proficiency on toward mastery is then up to you.

If you come blessed with programming skills, you're already most of the way there. In fact, the main problem for experienced programmers may be unlearning the strict practices you're used to. Chaos is something we don't usually expect or welcome from computing devices, but for the next few hundred pages it will be our friend and collaborator. Order and chaos may be mutually exclusive, but that doesn't mean they can't work together.

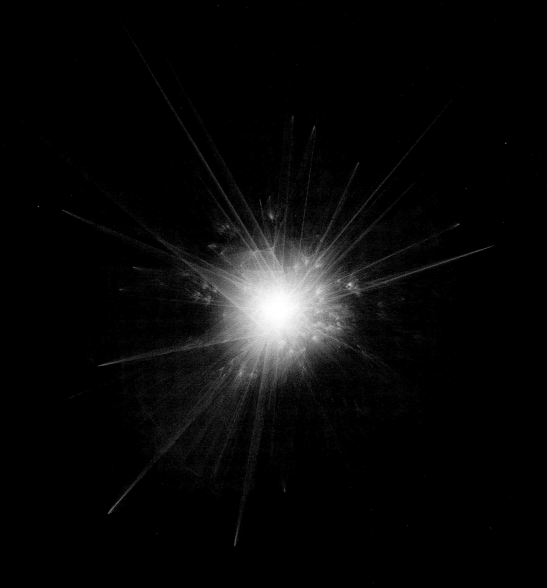

Figure i.8

Perth Arts Festival Branding (2010). Image from a print/video/online generative branding
project I created in collaboration with Brighton's FutureDeluxe (http://futuredeluxe.co.uk).
See http://vimeo.com/20096257 for the full story.

Order and chaos

The image in figure i.9 shows *Newton*, painted by William Blake in 1795. To the left of the picture are brightly colored flora and fauna, the complexity of the natural world. To the right is order, the precision of geometry and the compass. In the middle, between these two incongruous elements, sits Man.

Except, in this case, it isn't just *any* man, it's Isaac Newton, writer of *Principia Mathematica,* the founding work of classical mechanics. Blake's painting is a criticism of Newton's world view; he is turning his back upon the beauty of the natural world, his sole interest is in his scroll and compass.

William Blake was a Romantic, with a capital R. He was part of the Romanticism movement, the artistic, literary, and intellectual reaction to The Enlightenment of the late 18th century. The Age of Enlightenment was the time that heralded the birth of modern science, when purest reason

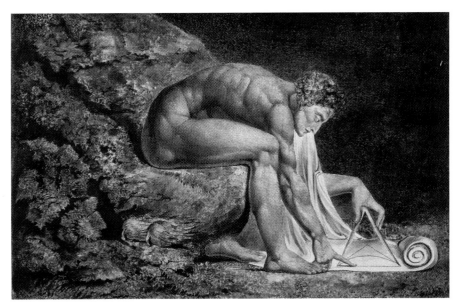

Figure i.9

Newton, by William Blake is a beautiful illustration of the incongruity between the chaos of nature and the precision of science and mathematics.

William Blake (1757–1827) *Newton*, ca. 1795, print with ink and watercolor, Tate, London

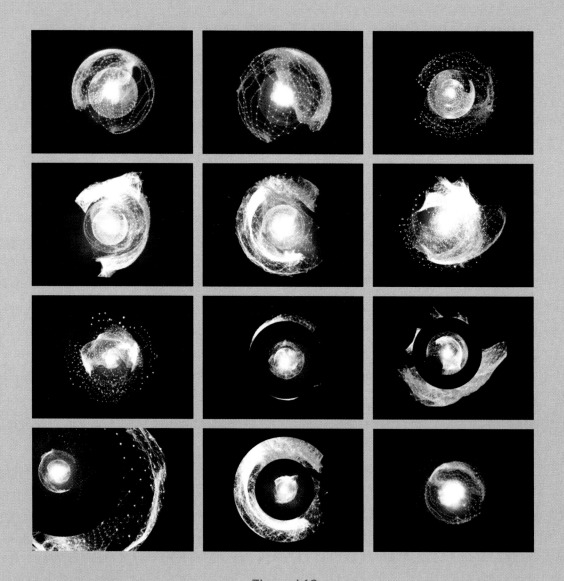

Figure i.10

Life in 2050 (2010), a video ident I created for a film festival, again collaboration with FutureDeluxe (http://futuredeluxe.co.uk). It was made using Perlin noise and deconstructed spheres, a process described in chapter 5. The finished film is at http://vimeo.com/10924639.

Figure i.11

Frosti (2010). Here, I reused the same system that generated the video work in figure i.10 for a print work.

was the dominant philosophical trend. The Romantics feared the coming godless world and clung to the dying remnants of an idea of natural idyll: the aesthetic, the rural, and the picturesque. They saw the future on their horizon, the world of the rational and scientific, the future we now live in. And it repulsed them.

Modern computer programmers may adopt the same pose as Newton. They spend their working days entranced before a screen, squinting at a glowing monitor in a dimmed office, making only the barest micro-movements with their mouse-hand and keyboard fingers, only vaguely aware of what is beyond the screen, outside the window, outside the city. The chaos of the natural world isn't welcome in this world of logic; unpredictability isn't something we want from a computer.

Figure i.12

Contact sheets for *Twill* (2010). This book's cover image was chosen from a run of several hundred generative images.

But the generative artist would be the programmer sitting facing the other direction, straddling that rock like Christine Keeler.[1] The generative artist comes from the world of logic to look toward the natural world for inspiration.

Is there an inherent contradiction in using computers to explore the realm of the organic? What could be less mechanical than the 1s and 0s of a humming box of electronics? Is generative art little more than a fool's errand?

And furthermore, if we declare our work as art, aren't we implying an intent to explore *emotion* and *aesthetic*? Can we reasonably expect to create works with emotional resonance using only procedures, logic, and mathematics? Relying on a computer to create an artwork and expecting it to connect with a viewer on a human level is surely akin to waiting for an infinite number of monkeys, with an infinite number of synthesizers, to write the perfect pop song.

Herein lies the challenge.

Order and chaos, simplicity and complexity, the mechanical and the organic, aren't necessarily at opposite ends of a spectrum. They're symbiotic, intertwined. Any line we might walk between the two is a knife edge. Our very existence is poised between entropy and order, between the

1. If you aren't old (or British) enough to remember the scandalous tale of John Profumo and Christine Keeler, visit Wikipedia to learn what a "defiant straddle" looks like: http://en.wikipedia.org/wiki/Profumo_Affair.

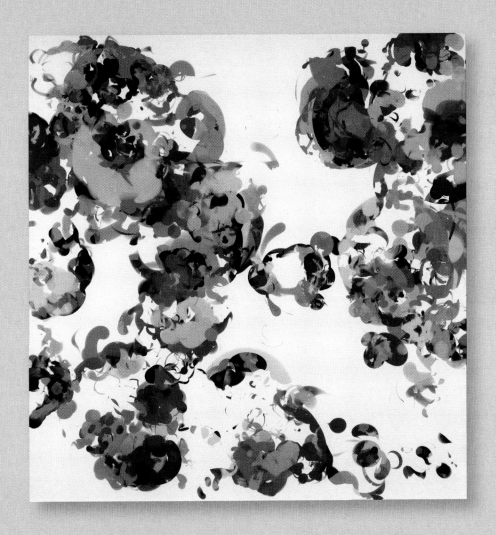

Figure i.13

Process 14 / Image 4 by C. E. B. Reas (2008). Casey Reas was one of the initiators of the Processing project. This print is from a series of Processing works exhibited at the bitforms gallery in New York in Spring 2008.

Figure i.14

100 Abandoned Artworks (2008–2010). Two years of weekly generative animation experiments, and their source code, which you can find at http://abandonedart.org. The code for many of the other works in this book can also be found there.

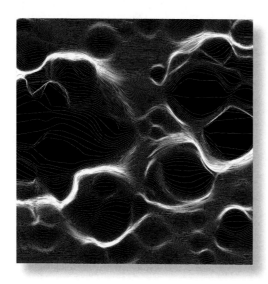 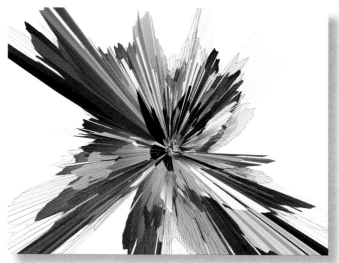

Figure i.15

(Left) Grid Distortion 02D 0018, a laser etching by Marius Watz (2010)

Figure i.16

(Right) KBGD01E 0012 by Marius Watz (2010)

turbulence of a hostile, chaotic environment, the natural world that we would find so difficult to survive unaided, and the simplicity of purest nothingness, the void that is equally fatal to our animal needs. We may think we have both mastered the chaos and fought off the boredom and madness of purest order. But any living being can testify that there is a constant fluctuation between the two. No matter how much order you impose upon your life, chaos is never more than a car crash away.

The mechanical and the organic, like order and chaos, are codependent; one couldn't exist without the other. The complex appeals to us as much as the simple, the organic as much as the mechanical. Fashion or mood may sway us more toward one or another in any given situation, but we never go completely over to one side or the other. For to do so is to stop living; to eradicate chaos is to become a robot; to eradicate order is to become a savage.

Fortunately, no one is asking us to take sides. The aim of generative art, if it has any aim at all, is to make something beautiful. We can attempt to use the mechanical to create the organic, starting from order and heading toward chaos, careful not to stray too far in one direction or the other. And if we become adept at this, we may be able to consider ourselves both programmer *and* artist.

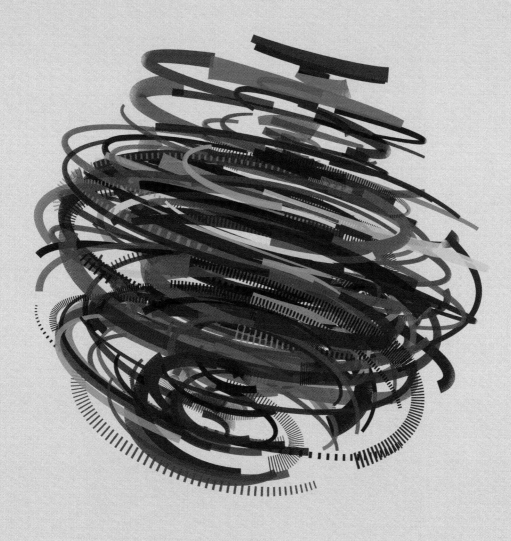

Figure i.17

Illuminations B by Marius Watz (2007). Marius, who provided this book's foreword, is another generative
artist whose work has been a great inspiration to me. Two more of his creations appear in figures i.15
and i.16. You can explore his other work and processes at www.unlekker.net.

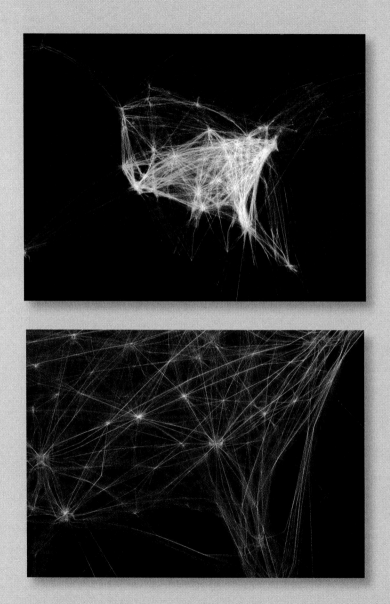

Figure i.18
Renders from Aaron Koblin's *Flight Patterns* (2005), a data-driven work that is discussed in chapter 7

Programming as poetry

Some may think there is something counterintuitive about using a programming language as an artistic tool, like using a forklift to perform a ballet or a T-square to draw a curve. This is because, traditionally, programming languages have been the realm of logic, structure, and organization. They're used for problem solving, modeling data, and accurate simulations. Highly logical activities such as these inevitably make coding unattractive to more creative thinkers. This is a waste. Programming languages are just tools; they don't belong to one community or another. They can be equally effective in the hands of a designer or in the hands of a systems architect, but the works created by these tool users will be radically different.

The history of programming has been toward ever-greater sophistication of organization. When computer scientists talk about design patterns, they don't mean aesthetics; in programming lingo, a design pattern is a useful framework for tackling programming problems homogeneously. The intention is that common challenges can be addressed the same way, in a move toward a more universal language of programming. The use and understanding of these tried and tested design patterns is typically the mark of a good programmer, but they're also a highly rigid way of

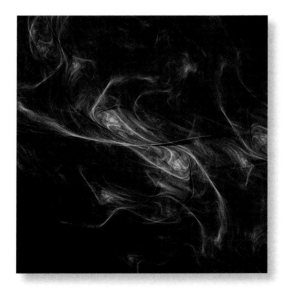

Figure i.19
Strange Symmetry 2 by Frederik Vanhoutte (2008)

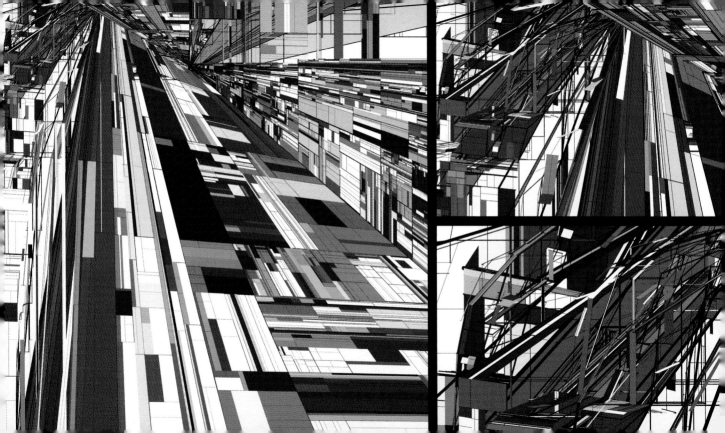

Orbitals (2009). Perlin noise applied to 3D circles. All the necessary principles behind this work are discussed in chapters 4 and 5.

Figure i.22

Broken Mirrors 1–4 (2011) Still from a gallery installation I built. It shows one of four generative animations created from the movement of the spectators viewing the piece

approaching language use. What we're doing with generative art is swimming against this tide and saying there isn't a right or wrong way to do anything. We can still use these fine practices, and we can learn a lot from them, but we shouldn't allow ourselves to be hindered by them. If rules exist, they're for the breaking.

But not the rules of programming syntax, unfortunately. It doesn't take long to discover that there's nothing iconoclastic about missing a semicolon: you just end up with broken code. This is an unfortunate reality.

A programming language is, after all, just another language. And a language can be spoken in many different ways, with a variety of accents or inflections. The programming language differs from languages such as English, German, and French only in that it's intended to facilitate communication between humans and machines, rather than humans and other humans. Because of this necessary unambiguity of human-to-machine communication, we wouldn't imagine that we could use a language like Java or C++ to write a poem. But if a language isn't capable of poetry, it has clearly lost its relevance on the human side of the equation.

My conjecture is that code can be poetry, and code can be *fun*. But we may have to sacrifice some of the rigidity, good design, and best practices of professional, commercial programming to enable this.

Figure i.23

LORMALIZED by Reza Ali (2010). Ali published this work as an app, so others could create their
own images using his system. You can download it from www.syedrezaali.com/.

Figure 1.24

Drawing With Particles by 01010101 (2009). Jerome Saint-Clair, aka 01010101, fashioned this image with moves of the
mouse, but the tool his mouse controlled was a generative particle system of 01010101's own creation.

Figure i.25

Happy Place by Jared Tarbell (2006). Agent-oriented behaviors at the micro level, producing emergent complexity at the macro level. If these words mean nothing to you right now, chapters 6 and 7 will explain.

The chaos artist

Declaring our work as "art" is a bold and arrogant thing to do. By doing so, we're saying that our work is beyond mere utility: it's an expression of our humanity and individuality. It may even be in the realm of the ineffable. Unfortunately, it may also be an expression of our pretentiousness, but let's try not to worry about that for now. If you're of the opinion that nothing in life is worth doing if it's without specific purpose or measurable value, you've picked up the wrong book.

Furthermore, to describe our work as "generative" art means we not only intend our work to express our individuality, but we also want it to express the chaos and abandonment of processes free of our control. Without this unpredictability, our art would belong in a box other than the one labeled *generative*. Generative artists are chaos artists. They have bred the unpredictable, welcomed it, harnessed it, and can fashion it into pleasing forms.

Common or garden chaos (as opposed to the mathematical kind, which we'll touch on in part 3 of this book) may seem anathema to the logician. Unpredictability is something unwanted in traditional programming practices, which is why more experienced programmers reading these words may be finding some of these ideas unpalatable. But trust me: it's for your own good. Nonlinear approaches to the familiar can be healthy for the brain. And, who knows, you may even be able to take some of these creative angles back to your coder day job and make yourself incredibly unpopular with your bosses and colleagues.

Chaos isn't to be feared. After all, we aren't doing anything more dangerous than making attractive imagery with computers. Seriously, what is the worst that can happen? To engage in generative processes means we are *expecting* the unpredictable—it isn't an unwelcome visitor. We'll become comfortable with a lack of control over our work. We'll embrace this chaos and learn to love it. ∎

Part

one

Creative Coding

> **"** The machine makes the music,
> but I created the machine...
> I don't know where responsibility lies
> in that situation. **"**

Autechre's Sean Booth, in interview, 2010

Generative Art:
In Theory and Practice

On first appraisal, the question "What is generative art?" may seem simple. But, as is the nature of all things generative, even this definition has an emergent complexity.

The elucidation most often cited in recent years is attributed to Philip Galanter, artist and professor at Texas A&M University, from his 2003 paper "What Is Generative Art? Complexity Theory as a Context for Art Theory":[1] "Generative art refers to any art practice where the artist uses a system, such as a set of natural language rules, a computer program, a machine, or other procedural invention, which is set into motion with some degree of autonomy contributing to or resulting in a completed work of art."

Although this is accurate and descriptive—and a long sentence with all the right words—a single phrase like this isn't enough. I don't think it quite captures the *essence* of generative art (GenArt), which is much more nebulous. In my mind, GenArt is just another byproduct of the eternal titanic battle between the forces of chaos and order trying to work out their natural harmony, as expressed in a ballet of light and pixels. But flowery crap like that isn't going to get us anywhere either

1. You can read Prof. Galanter's paper in full at www.philipgalanter.com/downloads/ga2003_paper.pdf.

We have to be careful treading around this topic, because we want at all costs to avoid trying to define "What is art?" which is an argument best left alone. The concept of art can be so fragile and fuzzy that if we were to prod it too much, it would evaporate. So, instead of trying to carve up a subject that doesn't want to be dissected in search of a pithy description, in the section that follows I'll take a more delicate and obtuse approach. We'll begin by examining what generative art *isn't*.

1.1 Not your father's art form

With more traditional art forms—sculpture, painting, or film, for example—an artist uses tools to fashion materials into a finished work. This is clearly doing it the hard way. With generative art, the autonomous system does all the heavy lifting; the artist only provides the instructions to the system and the initial conditions.

The artist's role in the production process may be closer to that of a curator than a creator. You create a system, model it, nurture it, and refine it, but ultimately your ownership of the work produced may be no more than a parent's pride in the work of their offspring.

This is hideously unfair, of course. We shouldn't underestimate the human role in the collaboration. In addition to the programming, the human contributes one other important skill: *aesthetic judgment*. It's feasible for computers to develop a sense of aesthetics (plenty of work toward this aim has been done within the field of evolutionary systems[2]), but it will never be the best division of labor in a human-machine creative partnership. If we need to calculate pi to a million digits, it would be a misappropriation of resources to set a human brain to this task. Similarly, it's probably best not to leave it to machines to decide what's pretty and what isn't.

Although GenArt is almost always abstract in nature, it can't be defined by the style of the work. The common factor of generative artworks is the methodology of its production, not the style of the end result.

Figure 1.1, for example, is an abstract work, and it's a monochrome work, but we can only say that it's a generative work if it happens to fit my claims as to how it was created. This particular arrangement of pixels may have been achieved in Adobe Illustrator (not by my cloddish paws,

2. Richard Dawkins' book *The Blind Watchmaker* (1986) is a good, accessible introduction to the topic of genetic algorithms and their application.

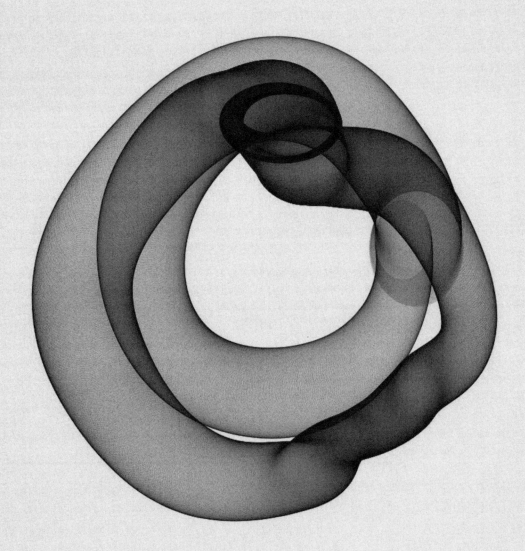

Figure 1.1
Tube Clock (2009)

I would hasten to add); by photography; or by pencil, paper, and scanner; and in all cases, it would still be a monochrome abstract. It may also still be generative, depending on the way each of these tools is used, but this isn't a given.

The tools used aren't the defining factor; it's the *way* they're used that provides the commonality. In this book, the programming language, specifically the Processing language, is the chosen tool. But that doesn't mean everything you create with that tool is generative. Programming languages are just ways of making computers do as they're told; there is nothing inherently generative about following orders.

To be able to call a methodology *generative*, our first hard-and-fast rule needs to be that *autonomy must be involved.* The artist creates ground rules and formulae, usually including random or semi-random elements, and then kicks off an autonomous process to create the artwork. The system can't be entirely under the control of the artist, or the only generative element is the artist herself. The second hard-and-fast rule therefore is *there must be a degree of unpredictability.* It must be possible for the artist to be as surprised by the outcome as anyone else.

Creating a generative artwork is always a collaboration, even if the artist works alone. Part-authorship of any generative work must belong in part to the mechanisms the artist uses: the system that generates it. Fortunately, anonymous autonomous systems aren't usually bothered if their unscrupulous artistic partners decide to steal all the credit.

To retain a necessary focus, this book discusses only one tool—the programming language—as a way of producing only one range of output: visuals. But generative methods may also be used to produce music, architecture, poetry, dance, storytelling or interactive experiences, and the autonomous systems behind their creation may also be mechanical, games of chance, natural phenomena, or subconscious human behavior. We'll touch on some of these alternative approaches later in the book.

1.2 The history of a new idea

Generative art has a history measured in decades, not long compared to other arts, which is probably why it's still on the periphery of the art world. Art colleges across the globe are churning out tens of thousands of painters, potters, fashion designers, and graphic designers every year, but the number of practicing generative artists in the world at present could probably fit comfortably onto a single Caribbean cruise liner (which would be a lovely idea if anyone fancies arranging it). This demographic is changing fast, though. As popular computing technology accelerates, more creative people are getting theirs hands on the tools and discovering this novel art form.

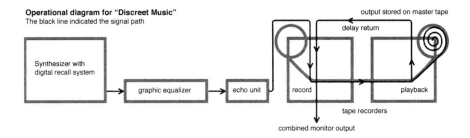

Operational diagram for "Discreet Music"
The black line indicated the signal path

Synthesizer with digital recall system → graphic equalizer → echo unit → record → playback

output stored on master tape
delay return
tape recorders
combined monitor output

Figure 1.2
Brian Eno's *Discreet Music* album included a diagram on the sleeve explaining the synthesizer and tape-loop feedback system by which the music had been produced.

The term *generative art* has only been in general use since the 1960s, but the concept has been with us much longer. Generative forms of music, for example, have been around since Mozart. His *Musikalisches Würfelspiel* (Musical Dice Game) was an early example of a generative artistic system.

The idea was to create a minuet by cutting and pasting together prewritten sections, making selections according to the roll of a die. Even with a single six-sided die, the number of possible combinations rises quickly: by 5 rolls, there are 7,776 possible combinations; and with 6 rolls, 46,656. These types of artistic parlor games became popular in the eighteenth century.

In the last century, composers such as John Cage, Karlheinz Stockhausen, and Brian Eno expanded on the idea of generative music.[3] John Cage's *4' 33"*, his controversial note-less piece defined only by its length, takes environmental ambient sounds as its only content, meaning no two performances of the work are ever the same.

Later, Stockhausen and Eno (and others) experimented with procedural methods of composition, where music is defined by a set of rules or conditions. Eno's *Discreet Music* LP (1975) is a fine example of this. The first side is a 30-minute piece created by a tape-loop feedback system. A synthesized melody was recorded onto a tape machine, the output of which was fed into a second tape machine. The output of the second machine was then fed back into the first machine and the overlapping signals recorded. We know of this process because Eno included a diagram of his setup on the back cover of the LP (see figure 1.2).

3. Even though Processing can be used to create generative music, this book focuses solely on the creation of visuals. Generative music is a huge and fascinating topic that warrants a book of its own. David Toop's *Haunted Weather* might be a good place to start.

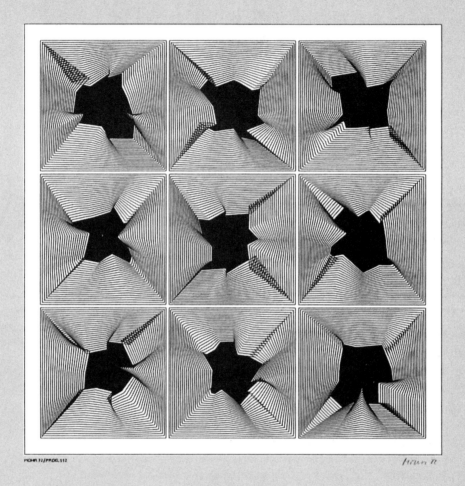

MOHR 72/PROG.112 [signature]

Figure 1.3

Lady Quark by Manfred Mohr (1972), one of the earliest *algorists* (generative artists who work
with computers). Mohr wrote his own software in order to explore his art.

Visual forms of generative art started emerging in the 1960s, first with computers outputting to plotters, then with visual display units (VDUs), and later in more sophisticated forms of print and video. Early pioneers from the plotter years were Frieder Nake, George Nees, Vera Molnar, Paul Brown, and Manfred Mohr (see figure 1.3), who published a collection of computer-generated artworks called *Artificiata I* in 1969.

But although the development of GenArt has been closely tied to the evolution of the computer, computers are just a useful convenience. The *real* tools of GenArt, the underlying constants to the various tools you can use, are the *algorithms*. Algorithms are a part of the natural world; they have a universality that transcends medium. So while the systems capable of creating GenArt change over time, evolving as technology evolves, the algorithms remain the same. Generative art may not be quite as old as art itself, but it may be said to be at least as old as mathematics.

This book is all about the algorithms. It's about the philosophy, aesthetics, and experimentation too, but mostly it's about the algorithms and the tools you use to explore them. You can, theoretically, perform the mathematics behind procedural GenArt with a stick of chalk and a large flat rock, but that would make life unnecessarily difficult—especially when we live among the ever-advancing sophistications of the twenty-first century and its remarkable digital toolset, which is what we'll look at next.

1.3 The digital toolset

If you're a practitioner within the digital medium (and it's difficult not to be these days), you likely already have a set of tools you favor for your creative endeavors. You've come to grips with a particular word processor or email client, so when you feel the need to craft words, you have the means to do so. You may also have invested time in learning a graphics package for when you're inclined to say it with pixels. On a more fundamental level, you've probably developed relationships, perhaps even dependencies, with your devices—MP3 players, phones, laptops— and have tamed them into serving your needs. Software and hardware alike, all of these are the tools in your digital toolbox. But how long-term are these man-machine marriages?

1.3.1 Perpetual impermanence

In periods of rapid technological innovation (of which our current time is one, but so has been pretty much every other era in human history) we become highly focused on the latest tools. We invest a lot of time in mastering their quirks, and we upgrade them frequently.

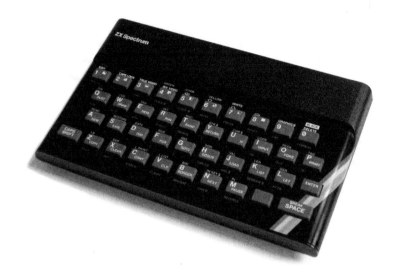

Figure 1.4

The ZX Spectrum: the machine I learned to program on. It was the cutting edge of British home computing circa 1982: 48 KB RAM, no hard disk, and no mouse. The lack of a visual operating system meant you had to learn basic programming skills just to be able to load a game.

Apple's range of laptops is updated annually, with the top of the range reaching higher and higher levels of power and convenience. An application like Adobe Photoshop has, on average, a major new release every 18 months, with a dollar price for each release in the hundreds. It would be unimaginable to buy a chisel, or a paintbrush, or a set square, knowing that it would be obsolete in two years, yet this almost-immediate obsolescence is unquestioningly accepted on the cutting edge of both hardware and software.

An unwritten complicity exists between users and manufacturers of technology. The manufacturer will have a roaring trade if every year it can deliver the same product to the same customer who bought it last year, but this is made possible only by the demand of the market: the users who eagerly await these upgrades and see value in every minor iteration. They're driven by the desire for the latest technology has to offer, and they're prepared to make the necessary sacrifices to have it within their grasp. This creates a cycle of perpetual impermanence, which marches the technology forward.

You should bear this in mind as you create digital artwork. If you work with pixels, there is already a fragility to the work you do: your art disappears the second the monitor is turned off. For this reason alone, many artists gravitate toward more tangible art forms such as print and sculpture (the decreasing prices of 3D printers promise some exciting possibilities for tangible generative art in the coming decade). Furthermore, if you become dependent on a machine to create your art, you know the machine and the software it runs are already halfway to obsolescence before you've taken them out the box. This isn't a bad thing, though, because the next generation will be capable of even more remarkable mathematical feats, enabling ever-broader artistic possibilities.

From our limited temporal perspective, the evolution of digital tools may seem to be in a uniformly positive direction, with every release bringing greater sophistication, speed, simplicity and/ or intuitiveness. Moore's Law; the 1960s observation that processing power is doubling, and its price halving, every few years, seems to be holding true and showing no sign of dropping away—which, for now, means the digital world is only ever going to get Faster! Better! Cheaper! But as we're swept forward on this breakneck digital tide, we may fool ourselves into believing that our functional friends are at an unprecedented level of sophistication, that they're the best our civilization can offer. But by what yardstick do we measure such sophistication?

1.3.2 The latest in primitive technology

We're in the very early days of digital technology. The computer is still in its first century—it's but an infant, and the art of human-computer interaction is still a work in progress. Applications such as Photoshop, Flash, GarageBand, After Effects, Illustrator, Final Cut Pro, Maya, syntaxes such as C++, Java, HTML, CSS, and so on, all do incredibly cool things and have changed the way our media looks and behaves. But they aren't tools with the simplicity or intuitiveness of the paintbrush or the scalpel. They're clearly much removed from pencils, pens, chisels, guitars, drums, trowels, and scissors, from natural and instinctual ways of expressing ourselves that have evolved over the millennia, rather than the last few decades. Compared this way, our digital tools appear extremely primitive in their usability, and at times quite an impediment to our creative flow. The purpose of a tool is not only to extend our capabilities; it should also enhance the flow of our creativity. The newest software gives us the power to fashion the world in ways that would have been unimaginable only 50 years ago, but there is still a long way to go in terms of a natural artistry to their use. Almost all of the more powerful tools have a steep learning curve and require dedication and constant use to master. A child can't quickly pick up Adobe Illustrator and draw a line. Even adults with a certain degree of techno-savvy can't come fresh to a program like Maya and find a way to express themselves within a few minutes. On the other hand, using a pencil or

a paintbrush, a child could instantly make some kind of statement involving line and color without having to learn any keyboard shortcuts. Their efforts would likely be rather amateur, it's true, but the important point is that they haven't been at all hindered by their tool, only empowered by it.

An art form is defined by its tools. The tools give an art form its grammar. If the nature of a tool means it's easy to perform one action or express one idea, and harder to perform another, the easier option will become more common. This is why so few landscape painters work in 3D, and why choreographers aren't interested in bowls of fruit. In this way, our tools have a greater influence on the work they're put into producing than you may realize. They can limit our creative choices at the same time they extend them.

The trick is to appreciate these parameters and to come up with new ways of using the tools, to avoid falling into tired and over-familiar practices. This applies to a programming language as much as it does a paintbrush. If you're an experienced programmer with a more formal grounding in your trade, that is one of the things I hope you'll get from this book: a fresh way of approaching the art of coding. And if you've never coded before, I hope you'll find novelty in these new toys. For what use is a paintbrush without an artist with the will to hold it?

1.4 Summary

We've explored what generative art *isn't,* and we've grudgingly accepted the limits of our primitive and impermanent toolset. Surely there must be something positive to take away from this chapter.

For starters, we've built a list a few things that, it's probably safe to say, generative art definitely *is.* It's:

- An algorithmic way of creating an aesthetic
- A collaboration between an artist and an autonomous system
- An exercise in extracting unpredictable results from perfectly deterministic processes
- A quest for that sweet spot between order and chaos
- A fresh, fun approach to coding
- A growing medium with huge potential

It may be early days for the digital toolset, but these technological marvels award us some novel powers of expression. At the same time, they have a huge bearing on the type of work we produce with them. The tool we'll focus on for the GenArt experiments in this book is a wonderfully simple language called Processing, which we'll get started with in the next chapter.

Processing: A Programming Language for Artists

In this chapter you're going to become a programmer. Although you don't necessarily need to know a programming language to experiment with generative art, you'll find it makes things a *hell of a lot* easier.

Obviously, one chapter probably can't cover *everything* there is to know about any one language, but I'm confident that in around 30 pages, I can introduce all you need to start getting creative with code: from Hello World, through basic syntax and functions, to publishing your work for print, video, or mobile phones.

But first, if you plan to invest a significant amount of time in learning a tool, I feel I must justify the choice of programming language I've made for this book. Even constrained as you are to the toolset of the early twenty-first century, you have an abundance of software choices for experimentation with generative visuals. The options range from expensive professional tools (such as Flash and 3ds Max) to free online resources (like HasCanvas and Scratch). But your time is precious, and you could never hope to master them all. For your purposes, you need just one. The best one.

To narrow it down, I came up with a few criteria. The language has to be easy, powerful, extensible, and well supported. I also wanted it to be equally adept at producing generative visuals for print and video, not just the computer screen. Most important, though, I don't want you to have to pay for it. Even with these demands, we're still spoiled for choice. This book could just

have easily been focused on openFrameworks (www.openframeworks.cc/), Context Free (www.contextfreeart.org/), Structure Synth (http://structuresynth.sourceforge.net/), NodeBox (http://nodebox.net/) or vvvv (http://vvvv.org/). And if you ever find yourself looking for a new toy to play with, you'll have fun exploring any of these. But I'm assuming that, for now, you're new to the world of programming, so you want something that suits an initial gentle learning curve while retaining the scope for advanced techniques and professional results. With this in mind, I propose that there is only one obvious choice: Processing.

The main reason I favor Processing, though, and the reason it warrants a book like this one at this point in its life cycle, is that I believe this one tool marks a significant advance in the democratization of programmatic art. To date, generative art has struggled to catch on outside of the realms of mathematics and computer science—fields that have never traditionally attracted those with more adventurous aesthetic obsessions. Processing is perhaps the first language to enable the creation of professional generative art by a general audience, not just computer scientists.

2.1 What is Processing?

Processing was conceived as a language for artists. It was developed as an open source project (initiated by Casey Reas and Benjamin Fry while at MIT) specifically intended to teach programming skills via the instant feedback of visuals. It's built on a much more complex and powerful language, Java, but greatly simplified and applied. As it has grown in popularity, the simplicity of the core language has been enhanced with third-party libraries, enabling it to also be put to other more sophisticated uses: drawing in 3D, reading XML, talking to MIDI or Arduino, or interfacing with other APIs (Flickr, Twitter, and so on).

Mozilla, the organization behind the open source Firefox web browser, has announced Processing for the Web, a project proposal for porting the Processing language and environment to the open web, so it can integrate with standard technologies like JavaScript and HTML5's **Canvas** tag. This would mean Processing could be run directly in the web browser, without a plug-in. Already, strides have been made in this direction with John Resig's Processing.js project, which implements Processing in JavaScript. There are also implementations of Processing in Ruby (http://wiki.github.com/jashkenas/ruby-processing/), Clojure (http://github.com/rosado/clj-processing), and Scala (http://technically.us/spde/), all of which have emerged as grassroots projects, typically through the work of a single coder, in the last two years. They're clear symptoms of the growing popularity of Processing and its potential for the future. The barriers for entry are dropping as the potential distribution opportunities are expanding.

Mastery of a programming language is perhaps the single significant barrier of entry to generative art. Although it may not be possible to pick up Processing instantly, the learning curve required to get started with Processing makes it accessible to a much wider range of technical abilities than other languages, while it still retains the power to be more than just a toy or learning aid. All tools, even the most basic, come with a learning curve. Your first efforts with a pencil will unlikely be great works of art; and although most of us are first introduced to handheld drawing implements as children, when our brains are most malleable, it may take years to master even this simplest of tools.

The programming language is at the other end of the complexity spectrum: it can't be encapsulated into a neatly tangible physical object, it requires a highly sophisticated chunk of hardware to run it (and is useless without it), and it's abstracted in a way that makes input and response not immediately apparent. Rather than the immediate feedback of sweeping a pencil against paper and seeing the line created, the process of write—run—amend (or write—run—debug) puts a gap between the artist and their work.

But, as previously mentioned, the Processing language, once tamed, can assist you in your art, and become your collaborator as well as your instrument. The programming language, with mathematical and logical aptitudes far beyond your own, can do all the heavy lifting and leave you to concentrate on the finesse.

New programmers will find that there is a logic to coding that becomes familiar with time, appealing to the ordering, categorical instincts of the left brain. I hope, for the non-programmers who have picked up this book, that by the time you're finished with it, the idea of programming will hold no trepidation. After you've made friends with your tool and established a confident working relationship, you can get on to having some fun with your new collaborator.

2.1.1 Bold strides and baby steps

The starting point for these explorations, as well as the Processing download, is the Process*ing* website (see figure 2.1). You can find the latest version at www.processing.org/download/. It's currently supported for Mac OS X, Windows, and Linux. The screenshots used throughout these pages are taken from the Mac version, but the interface is nearly identical for all the supported platforms.

Note that it's worth checking back to the Processing download page occasionally, because revisions to the language are frequent. The application went through 161 versions prior to its 1.0 release in November 2008, and it continues to be updated and improved. There are also many other resources to be explored at www.processing.org, including some great getting-

Figure 2.1
Processing.org: an invaluable resource for tutorials, reference, and discourse. It's also the place to download the latest version of Processing.

started tutorials by Dan Shiffman and Ira Greenberg in the Learning area, lots of code examples demonstrating various features of the language (again in the Learning area), and an active forum in the Discourse area. And while you're bookmarking things, you might also like to add both my site (www.zenbullets.com) and the Abandoned Art site (www.abandonedart.org) to your list; where you'll find the downloads for this book as well as many other generative artworks and the source code behind them.

The following section will introduce you to the technology, show you around the *Processing Development Environment* (PDE), and point out where to write your first line of code. If you've coded before, you may not need much more than this to get you started. But if you do, the rest of the chapter is a whistle-stop tour of the language essentials, written specifically with the beginner in mind. It will take you through the key concepts of Processing and programming languages in general, and arm you with everything you need to start experimenting. If you're a beginner, this section is essential.

If you have programming experience but haven't tried Processing before, you may skim these pages a little faster than the rank amateur. But every programming language has its idiosyncrasies, so it will be useful for you to learn how Processing uses concepts such as the frame loop, for example. If you've programmed Java or any ECMA-based language (ActionScript, JavaScript), Processing should come naturally to you.

One of the joys of open community projects such as Processing is that there is no shortage of free resources on the web in support of the product. If you find that the tutorials in this chapter don't suit your pace, plenty of free options are available to help you. Again, I refer you to www.processing.org as a starting point.

Okay, you've said hello to Processing; next, let's see if you can get Processing to say it back.

2.1.2 Hello World

After you've downloaded Processing, installed it, and run it for the first time, you'll see something similar to figure 2.2.

This window is called the Processing Development Environment (PDE). Quickly, before blank-page paralysis sets in, let's type something. Key the following in the main window:

```
ellipse(25, 25, 50, 50);
```

Then, click the Run button: [▶]. What do you see? The *output window* should pop up (see figure 2.3). In it is a 100 x 100 pixel canvas within which has been drawn an ellipse, center point at coordinates 25, 25 (measured from upper-left), width and height 50 pixels. This is the visual programming equivalent of Hello World.

If you're new to coding, in only one line you've already mastered two programming concepts. You've called a function (**ellipse**) and passed it a number of parameters (**x**, **y**, **width**, and **height**). You can think of a function as a service you use to perform a certain task. Sometimes you feed it parameters; sometimes it only needs to be called. It may give you a value back, or it may just perform the task it's designed for—such as drawing to the screen. Later in this chapter, you'll write your own functions; but before you get there, you'll test a number of the core functions built into Processing, of which **ellipse** is but one. If you click the Help menu and select Reference, you'll see a full list of the others. The reference is also online at http://processing.org/reference/.

Figure 2.2
(Left) The empty PDE window: the first thing you'll see when you download and run Processing

Figure 2.3
(Right) Hello World. The output window shows the result of your commands.
The single line **ellipse(25, 25, 50, 50)** drew a circle 50 pixels in diameter with its center at point 25, 25.

Syntax matters

There is a certain fragility to the syntax of most programming languages. In a human language, if you were to mistakenly capitalize a word in a sentence—for example, *Ellipse* rather than *ellipse*—it might look odd, but the meaning would still be intact. But try this in a programming language, and it will break.

Similarly, whatever you do, don't forget the semicolon at the end of an instruction. The semicolon is the Processing syntax equivalent of a full stop. Whitespace doesn't matter—you can use a new line for every statement you write, or run them all along the same line, as long as each statement has the semicolon to terminate it. Forgetting the semicolon is a common cause of errors.

2.2 Programmatic drawing

Everything you need to know to start programming in the Processing language is contained in this and sections 2.3 and 2.4 to follow. After reading all three, you'll have the basics not just of Processing but also of programming in general. At their core, all programming languages boil down to the same types of structures: *variables*, *loops*, and *functions*. When you've got a grip on these concepts in Processing, you'll find you have half an understanding of many other languages and will be the toast of your local chess club.

I appreciate that some of this may be a little unintuitive at first. If you feel you're in unfamiliar territory as you wander through, I'd suggest you take this chapter very slowly. Code along as we go, and take the time to play around with trying every code chunk until you feel in control; only move on when you're happy. There is no time limit, and your patience will be rewarded. Experienced coders are probably already speed-reading chapter 3 at this stage, so I'll assume I'm not catering to them from here on.

From chapter 3 onward, there's a lot of fun to be had with graphical programming, getting messy and breaking rules. But before you can break any rules, you have to learn a few of the rules you'll be breaking. It's tedious, I know; but remember that if you want to effectively insult a Frenchman, you'll be a lot more effective at it if you've learned French first.

You'll start with drawing a few simple shapes.

2.2.1 Functions, parameters, and color values

In the previous section, you downloaded Processing, typed your first one-line script, and published it to the output window. You'd called your first function (**ellipse**) and passed it a number of parameters (**x, y, width**, and **height**). Now, let's try a few more.

Open a new window, and type the following into the PDE window (see figure 2.4). Note that the lines beginning with **//** are comments, a place where you can put human-readable text. The **//** indicates that Processing shouldn't try to run that line. You can also use the notation **/* ... */** to spread comments across more than one line:

```
// setup and background
size(500, 300);
smooth();
background(230, 230, 230);
// draw two crossed lines
stroke(130, 0, 0);
strokeWeight(4);
line(width/2 - 70, height/2 - 70, width/2 + 70, height/2 + 70);
line(width/2 + 70, height/2 - 70, width/2 - 70, height/2 + 70);
// draw a filled circle too
fill(255, 150);
ellipse(width/2, height/2, 50, 50);
```

Click Run, and you should see something like figure 2.5. What you've written in the PDE is a list of functions. I'll walk you through them and explain what each one does.

First, set the size of the canvas to 500 pixels by 300 pixels:

```
size(500, 300);
```

Turn on smoothing, which anti-aliases the lines you draw so they don't look jaggy:

```
smooth();
```

And set a grey background color:

```
background(230, 230, 230);
```

The three parameters to the **background** function are RGB values—Red, Green, Blue. Each value is a number from 0 to 255 defining how much of that color goes into the mix. Together, these three numbers give you 1.6 million combinations of colors you can use. In this case, because

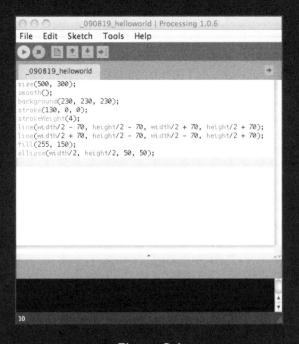

Figure 2.4

The PDE with your new script

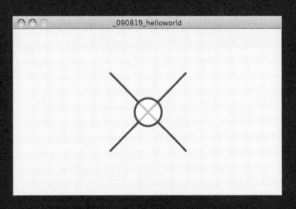

Figure 2.5

The output window showing the result of the commands you've just written

all three RGB values are the same, the result will be a grey color (any even mix yields a shade of grey). You can use a shorter version of the function for grayscale, with just one parameter: **background(230);**. This produces the same result as the three-parameter version.

Many other graphical applications use this RGB notation. If you're unfamiliar with it, try a few different values from 0–255 in each of the **background** parameters to get used to this way of color mixing. You may also have seen hex values used to denote color values (as in HTML or Photoshop), such as #FF0000, which denotes red. This notation is similar; the three RGB values are expressed as hexadecimal (base 16) character pairs. Each two characters represent a color value: in the example, Red: 255 (ff), Green: 00, Blue: 00.[1]

You can use hex values in Processing if you prefer. **background(#E6E6E6);** produces the same result as **background(230, 230, 230);** (E6 hexadecimal = 230 decimal).

Next, let's look at the stroke.

2.2.2 Strokes, styles, and coordinates

Returning to the code walkthrough, these are the next two lines:

```
stroke(130, 0, 0);
strokeWeight(4);
```

They tell Processing to set the color of your stroke (imagine this as your virtual pen) to a medium red (using RGB values again), and set the pixel thickness to 4.

After this, you draw a line in the stroke style you've just set:

```
line(width/2 - 70, height/2 - 70, width/2 + 70, height/2 + 70);
```

For this function, the parameters are (**startx**, **starty**, **endx**, **endy**); but in this case, you haven't simply passed static values. In the slot for each of the four parameters is a simple sum. The result of each sum is passed as the parameter. Remembering that you previously defined a width and height of 500 x 300 pixels, you can calculate that the resulting drawn line will be from point (180, 90) to point (320, 220). (Coordinate values are always measured from upper-left.)

At this point, you may question why the function isn't just written **line(180, 80, 320, 220)**, because this would perform exactly the same action. The reason is that you're trying to draw a cross relative to the center of the canvas. Yes, you know that your canvas is 500 x 300, because you set these values yourself only a few lines back; but if you use Processing's knowledge of the

1. For more information about hex notation, see www.web-colors-explained.com/hex.php.

canvas **width** and **height**, instead of relying on your human faculties, then if you go back and change the **size** function at any point—say, to **size(600,150)** (go on, try it)—the crossed lines will still meet at the center point.

An *absolute* coordinate (250, 150) never moves. But a *relative* coordinate (width/2, height/2) dynamically repositions itself relative to the size of the canvas.

The next line of code does the same, drawing a second line relative to the center point to complete the cross:

```
line(width/2 + 70, height/2 - 70, width/2 - 70, height/2 + 70);
```

This is a good point to introduce another programming concept: the *variable*.

2.2.3 Variables

You can see that you're performing the same calculation (**width/2** and **height/2**) multiple times. Wouldn't it be neater if you did it only once? Your code will be easier to read, and it will execute faster if the processor has to do fewer calculations.

When you get into more complex coding, you'll see that one of the biggest limitations is speed. The CPU in any machine can perform only so many calculations per second. It may not matter at this point when you're managing just a handful of instructions; but it won't be long until you're performing many thousand calculations per second, so it's worth developing a consideration of efficiency. If there is ever a way to easily reduce the number of calculations you're performing, you should take it.

Try changing the two cross-drawing lines to the following:

```
float centX = width/2;
float centY = height/2;
line(centX - 70, centY - 70, centX + 70, centY + 70);
line(centX + 70, centY - 70, centX - 70, centY + 70);
```

Here you declare two variables to hold the result of a calculation. Think of a variable as a box in which you can put only one thing of a certain type; but the thing you put in may, um, vary (hence *variable*). You have to declare your box before you can use it, and give it a name (which can be anything you want), although you don't necessarily have to put anything in it at first. The following is a valid way of declaring and filling a variable:

```
float centX;
centX = width/2;
```

You declare a variable by defining the type of data you'll be putting in it, in this case a **float**. A **float**? "What's a **float**?" I hear you cry. Table 6.1 lists all the built-in variable data types you have to choose from.

Table 2.1 The most common Processing data types

DATA TYPE	EXAMPLE OF USAGE	DESCRIPTION
char	char varName ='a';	A letter or Unicode symbol, such as **a** or **#**. Note the single quotation marks used around the symbol.
int	int varName = 12;	An integer (a whole number). Can be positive or negative.
float	float varName = 1.2345;	A floating-point number. A number that may have a decimal point.
boolean	boolean varName = true;	A true or false value. Used for logical operations because it can only ever be one of two states. (It can also be undefined, but this would resolve as false.)
byte	byte varName = -127;	A less commonly used data type, which can only store a numerical value between -127 and 128. It's most useful when you need to communicate with the serial port, which you won't do in this book.
String	String varName = "hello";	A list of chars, such as a sentence. Note the capital *S* on **String**, signifying that this is a composite type (a collection of **char**s).

Next, let's look at fill colors and alpha values.

2.2.4 Fills, alpha values, and drawing order

Okay, we've thoroughly deconstructed the drawing of two crossed lines. The final two lines of the script draw the circle:

```
fill(255, 150);
ellipse(width/2, height/2, 50, 50);
```

What you're doing here, before you draw the circle, is setting a *fill* color. The fill is the area within the lines of a shape. Using this fill value and the stroke you previously set for the crossed lines, the final command draws a circle (an ellipse with equal width and height). You set the fill color using the single color value 255 (the grayscale notation), which is white. But you also have a second parameter that sets the *alpha* value—the transparency of the color—again, a number 0–255.

An alpha value of 0 is fully transparent, whereas 255 is fully opaque. Any time you define a color, you also have the option of giving it an alpha value. If you like, go back and try adding an alpha parameter to your stroke color too. With the three-parameter RGB syntax, the alpha value is the fourth parameter:

```
stroke(130, 0, 0, 50);
```

The order in which you've written the functions means that you first draw two solid lines and then place a semitransparent circle on top of them. The list of functions that make up the program are executed in the order they're given. If you change the order so that the ellipse is drawn before the crossed lines, the point where they cross will be above the semitransparent white circle, so the lines will appear solid. Try the following code if you don't believe me:

```
size(500, 300);
smooth();
background(230, 230, 230);

float centX = width/2;
float centY = height/2;
stroke(130, 0, 0);
strokeWeight(1);
fill(0, 40, 0);

ellipse(centX, centY, 30, 30);
line(centX - 70, centY - 70, centX + 70, centY + 70);
line(centX + 70, centY - 70, centX - 70, centY + 70);
```

The first section of the code sets up the drawing and creates the background. Next, you set the stroke and fill. Finally, you draw the circle followed by two lines.

The order of execution is relevant not only to the layering of your drawing but also to the styles you set. Processing is state-based, which means that when you set a style (such as the color or weight of the stroke), that state will be maintained until you set it to something else. In the example, you call **stroke** and **strokeWeight** before drawing anything, so all the lines drawn are

of the same style. But you can change these settings as often as you please; whenever a line is drawn, it uses whatever setting was received last. Here's an example that changes the stroke styles between shapes:

```
size(500, 300);
smooth();
background(230, 230, 230);

stroke(130, 0, 0);
strokeWeight(1);
line(width/2 - 70, height/2 - 70, width/2 + 70, height/2 + 70);
line(width/2 + 70, height/2 - 70, width/2 - 70, height/2 + 70);

stroke(0, 125);
strokeWeight(6);
fill(255, 150);
ellipse(width/2, height/2, 50, 50);
```

The result is shown in figure 2.6.

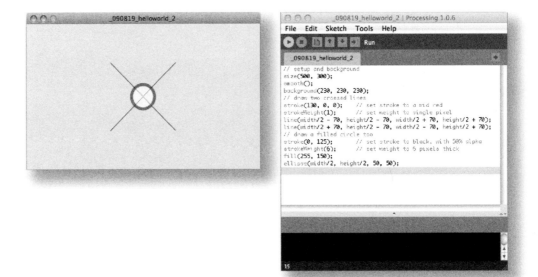

Figure 2.6
Commands such as stroke, fill and strokeWeight set the drawing style before a shape is drawn.

If you don't want your ellipse (or any other shape) filled, you can use the function **noFill** (a function with no parameters) to remove the fill entirely. Similarly, if you want to turn off the stroke, call **noStroke**.

This covers the basics of drawing in Processing. Feel free to take a little time to try a few commands to get used to the coordinate system; or perhaps pick a few other shapes from the Processing reference, such as **rect** to draw a rectangle or **quad** for a non-right-angled quadrilateral. I'm not going to give you any clues as to what the **triangle** function might create.

Once you're happy with your drawing skills, next you'll learn a little more about how to organize code and control decisions, as we introduce animation.

2.3 Structure, logic, and animation

So far your scripts have been nothing more than a short list of instructions to perform, after which they stop. But with anything above the most basic level of simplicity, you need to go a little further: you need ways to group instructions and make decisions. It's time to step it up a notch.

2.3.1 The frame loop

This section introduces a concept that is Processing specific (although it exists in many other tools too): frames. The word *frame* can mean a variety of things within the computer sciences, but our meaning is the movie industry sense—a single still image which, if we flash enough of them faster than the eye can see, gives the illusion of animation.

With Processing, a frame loop redraws the screen continuously. If you instruct Processing to do so, you can use this feature to add the dimension of time to your two-dimensional visuals and can create works that grow and move.

To enable this way of drawing to the screen, you need to begin putting your code in function blocks. A *function block* is a way of chunking a group of commands together. Processing sets aside two special blocks for frame-based scripting: **setup()** and **draw()**. The code inside the **setup()** function block is called once when the program launches, so it should contain all your initialization code—setting the canvas size, setting the background color, initializing variables, and so on. The code you write inside **draw()** is then called repeatedly, triggered on every frame. You can set the speed with which **draw()** is called by using the **frameRate** function. If you give it a number (12, 24, 25, and 30 are typical), it will attempt to maintain that rate, calling **draw()** regularly. Otherwise, it will perform the frame loop as quickly as the machine can handle.

Generative Art | Pearson

Note that if you're performing many complex instructions with every frame, your machine may not be able to process the code as fast as the frame rate you've specified. It will loop as fast at it can, which may result in not just a lower frame rate, but potentially an irregular one as well.

Let's look at an example. Open a new script, and enter the code in the following listing. Don't worry if you don't understand all the instructions in the function blocks—a few more new concepts are being introduced here that you'll step through in the next few pages.

Listing 2.1 **Organizing code into** setup() **and** draw() **function blocks**

```
int diam = 10;
float centX, centY;

void setup() {
  size(500, 300);
  frameRate(24);
  smooth();
  background(180);
  centX = width/2;
  centY = height/2;
  stroke(0);
  strokeWeight(5);
  fill(255, 50);
}

void draw() {
  if (diam <= 400) {
    background(180);
    ellipse(centX, centY, diam, diam);
    diam += 10;
  }
}
```

24 frames per second

Clears background every frame

Increases diameter for next loop

When you run this you'll see a circle grow toward you in the output window, stopping when the diameter reaches 400 pixels (see figure 2.7). The diameter and the center points are kept in variables, with the center points calculated in **setup()**. The frame loop then checks that the diameter is smaller than 400, redraws the background, draws the circle, and increases the diameter by 10 for the next time it goes around the loop. The effect is that it draws a circle of diameter 10, 20, 30, and so on until the **diam** variable gets to 400. Note that the frame loop continues to be called over and over after the circle has reached its full size, but the **draw()** script is no longer drawing anything.

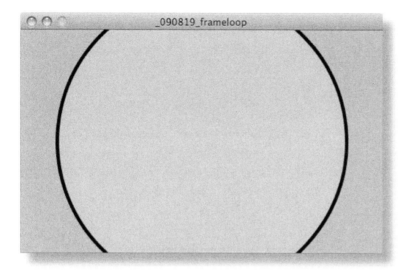

Figure 2.7

A circle drawn using a frame loop. When you run the script, the circle grows
from a diameter of 10 to 400.

As soon as you start using function blocks, you lose the convenience of being able to write commands outside of function blocks, which is what you've been doing so far. But don't look back—that capability was just a feature to improve the learning curve (thanks, Processing). You're welcome to continue programming long lists of sequential commands if you choose, seeing how you're so good at it now, but you can only go so far with that formatting.

Notice that you still declare your variables outside of the function blocks. This is fine syntactically: declaring variables outside of the function blocks means the contents of those variables are available to any and all function blocks in the script. If you define a variable within a function block, rather than outside it, that variable is only available within that block. It's good practice to do this if a variable is only needed within a single function (then the processor doesn't have to remember that value and can free up its memory for some other use).

This is called *variable scope*. Variables inside functions are called *local*: they only exist in that locality. Variables outside of functions are called *global*: they're everywhere. A variable with an unintended scope is a common programming bug for amateurs and experts alike, so it's one of the first things to check if your code is behaving unexpectedly. Many programmers use an underline (_) symbol to preface the names of global variables, so they don't get confused. For example:

```
int _num = 20;

void draw() {
    int inc = 10;
    _num = _num + inc;
}
```

Here, the first line declares a global variable (**_num**), whereas the **inc** variable in the function block is local.

The chunk of script in listing 2.1 contains a number of other new concepts for the nonprogrammer. Before you continue playing with the frame loop, let's look at those in more detail.

2.3.2 Writing your own functions

First there is the function block itself. The syntax of a function block is

```
returnType funcName([parameters]) {
    // code in here
}
```

The return type of the **setup()** and **draw()** functions is void, which is Processing's way of declaring that the function doesn't return anything at all. There are no required parameters to these functions either. The other valid return types for functions are the same as the data types for variables: **String**, **char**, **int**, **float**, and so on.

The idea of a function returning something will make more sense when you start creating functions of your own. Open a new script, and try this:

```
void setup() {
    int x = AddNumbers(1,2);
    println(x);
}

int AddNumbers(int a, int b) {
    int returnValue = a + b;
    return returnValue;
}
```

The first function **setup()** is automatically called by Processing when the script is launched. But the second function **AddNumbers** is one of your own and won't do anything until you call it. You do this within the **setup()** function: define an integer variable **x**, and set its contents to the return value of the custom function **AddNumbers(1,2);**. You define the return value of your custom function as an **int** also; otherwise, you'd get an error. You also define the data type of the two parameters the function requires, so it knows what to expect.

The custom function adds together the two parameters it's passed, puts the result in a variable, and returns that variable. If you give a function a return type, there must be the keyword **return** somewhere within the function; otherwise it throws an error. After the function has completed its job and the returned value has been put into variable **x**, Processing continues to execute the commands in the **setup()** function block. The line **println(x)** outputs the value of this variable to the console window (the black window below the text editor in the PDE). This script has no visual output, so the output window is an empty canvas.

2.3.3 Operators

Within your custom function is another new programming concept: an operator, **returnValue = a + b**. Nothing to worry about here—it's just math. The full list of operators is in table 2.2.

You can group your operators and define the order they're dealt with by using brackets, just as you do in conventional mathematical notation:

```
float a = 45;
float b = 5;
float c = 4;
float sum1 = (a + b) * (b * c);
float sum2 = a / (b + c);
```

In this example, **sum1** will contain 1000 (50 * 20), and **sum2** will contain 5 (45 / 9).

Note that we use floats where the result of a sum may not necessarily be a whole number.

There are also a few mathematical functions you'll find useful:

- **ceil()**—Rounds up to the nearest whole number
- **floor()**—Rounds down to the nearest whole number
- **round()**—Rounds up or down to the nearest whole number
- **min()**—Returns the smallest of the list of numbers passed
- **max()**—Returns the largest of the list of numbers passed

Table 2.2 Operators used in Processing

OPERATOR	NAME	EXAMPLE	EXPECTED RESULT
+	Addition	num = 45 + 5;	**num** becomes equal to 50.
-	Subtraction	num = 45 – 5;	**num** becomes equal to 40.
*	Multiplication	num = 45 * 5;	**num** becomes equal to 255.
%	Modulo	num = 45 % 5;	**num** becomes equal to the remainder of 45 / 5 (0).
/	Division	num = 45 / 5;	**num** becomes equal to 9.
++	Increment	num++;	The value of **num** increases by 1.
--	Decrement	num--;	The value of **num** decreases by 1.
+=	Add assign	num += 4;	Adds 4 to the value of **num**, and puts the result back in **num**.
-=	Subtract assign	num -= 4;	Subtracts 4 from the value of **num**, and puts the result back in **num**.
*=	Multiply assign	num *= 4;	Multiplies the value of **num** by 4, and puts the result back in **num**.
/=	Divide assign	num /= 4;	Divides the value of **num** by 4, and puts the result back in **num**.
-	Negation	minusnum = -num;	Multiplies the value of **num** by -1.

The three rounding functions are most useful when you're converting from floating-point numbers to integer values:

```
int centX = floor(width/2);
```

Without the **floor()** function, it would throw an error because if the width is an odd number of pixels, the result is floating-point number. The **floor** function prevents the error and ensures that you're always dealing in nice whole numbers (and you're not going to be able to see the difference if your center point is half a pixel off anyway).

The Processing language includes a lot more sophisticated math functions, some of which you'll use later in this book's experiments. If you want to leap ahead and try some of your own code-based fun, look at the available functions in the Processing reference and play around.

2.3.4 Conditionals

The final new element in the circle-drawing script is the conditional:

```
if (diam <= 400) { ... }
```

A conditional checks that a condition has been met before executing the code inside the block marked by the braces that follow it. In this case, the conditional asks whether the value of **diam** is less than or equal to 400. If it is, the code in the block executes. If not, the code in the block is skipped:

```
// check a condition
if (diam <= 400) {
    // execute code between the braces
    // if condition is met
}
```

You can also use an **else** clause to provide a block of code to be executed if the condition isn't met:

```
if (diam <= 400) {
    // execute this code if diam <= 400
} else {
    // execute this code if diam > 400
}
```

If you imagine the flow of execution as a trickle of water running down the script, by setting a conditional you're effectively creating different channels for the stream to follow. With an **if ... else** clause, the stream can go one of two ways. **if** on its own means the stream either goes through the block or goes around.

The comparison operators you can use are as follows:

- **==** equal to
- **!=** not equal to
- **>** greater than
- **<** less than
- **>=** greater or equal to
- **<=** less than or equal to

You can also use logic operators to group conditions

- **||** logical OR
- **&&** logical AND
- **!** logical NOT

Here are a few examples:

```
String likeStr;
if ((likeStr == "pina colada") || (likeStr == "getting lost in the rain")) {
    println("come with me and escape");
}
```

Note also that conditions can be nested as deeply as you like. The following is valid code:

```
int man = 5;
int devil = 6;
int god = 7;
if (man == 5) {
    if (devil == 6) {
        if (god == 7) {
            goToHeaven("monkey");
        }
    }
}
```

But in this case, the same result can be achieved as follows:

```
if ((man == 5) && (devil == 6) && (god == 7)) {
    goToHeaven("monkey");
}
```

Now you're starting to get the idea of programmatic flow and trusting the logic to make decisions for you. Next, in the final chunk of programming essentials, we'll look at one of the few things our calculating machines can do better than us humans: repetition.

2.4 Looping

There is one last core programming concept you'll need to in order to call yourself a coder: the *loop*. After that, we're finished, I promise. The ability to take a single instruction or group of instructions and repeat it hundreds, thousands, or millions of times is a key advantage of programmatic drawing over any other comparable creative process. This is a very straightforward way to scale ideas.

You have already encountered one working loop in the previous examples: the frame loop. The chunk of code within the **draw()** function is called every time a new frame is entered, so the code is executed repeatedly for as long as the program is running. You can use this to perform repeating actions if you want, but this isn't the only loop available to you. You can code your own loops, too.

Reload the circle drawing frame-loop script from a few pages back, and let's try it.

2.4.1 While loops

A code loop looks something like this:

```
int bass = 99;
while (bass > 0) {
   println(bass);
   bass--;
}
println("how low can you go");
```

This outputs the value of **bass** to the console window 99 times. The **while** command checks a condition and, if the condition is met, executes the code inside the braces; it then loops back up to the top of the block. The execution continues to the final line only after the condition is no longer met (in this case, when **bass** is 0).

Note that if you don't include the **bass--** line inside the loop, which subtracts 1 from the number every time it loops, the condition will never be met and the loop will go on forever. This is one of those errors the compiler isn't always clever enough to spot when you click Run. If your code includes an infinite loop, it can lock up your system, and you may have to force-quit Processing to escape it. So be careful out there, kids.

Let's put this into action. Modify the circle script with the additions highlighted in the following listing, and then run it.

Listing 2.2 **Drawing with a while loop**

```
int diam = 10;
float centX, centY;

void setup() {
  size(500, 300);
  frameRate(24);
```

(continued on next spread)

Generative Art | Pearson

```
  smooth();                                                            (Listing 2.2 continued)
  background(180);
  centX = width/2;
  centY = height/2;
  stroke(0);
  strokeWeight(5);
  fill(255, 50);
}

void draw() {
  if (diam <= 400) {
    background(180);

    strokeWeight(5);
    fill(255, 50);
    ellipse(centX, centY, diam, diam);

    strokeWeight(0);
    noFill();
    int tempdiam = diam;
    while (tempdiam > 10) {
      ellipse(centX, centY, tempdiam, tempdiam);
      tempdiam -= 10;
    }

    diam += 10;
  }
}
```

Loop within loop

Increases diameter for next loop

Here you have a loop within a loop. You copy the **diam** value into another variable; and then, every time you draw a circle of whatever **diam** you're currently at, a second loop draws circles inward, decreasing the diameter back to 10 in 10-pixel jumps. You can see the effect in figure 2.8.

Notice how you have to add extra lines to reset the stroke and fill; otherwise, the next time the frame loop was triggered, the previous settings would be applied.

2.4.2 Leaving traces

There is actually a much easier way of drawing concentric circles though. Try the following.

Listing 2.3 Concentric circles drawn using traces

```
int diam = 10;
float centX, centY;

void setup() {
  size(500, 300);
  frameRate(24);
  smooth();
  background(180);
  centX = width/2;
  centY = height/2;
  stroke(0);
  strokeWeight(1);
  noFill();
}

void draw() {
  if (diam <= 400) {
    // background(180);   comment out this line
    ellipse(centX, centY, diam, diam);
    diam += 10;
  }
}
```

Again, you see the same concentric rings from figure 2.8, but with fewer lines of code. The crucial change is that you comment-out **background(180);**, the command that clears the image every frame (and forces you to redraw everything every time). If you don't clear the image, you draw over the top of the previous frame. The animation of the growing circle is a series of frames of circles at growing diameters. If you don't clear the frame, you can see the traces your movement leaves.

You can use this to great effect. Try changing the **noFill();** line to **fill(255, 25);**, giving each circle a highly transparent white fill color (see figure 2.9).

Even though the transparency is barely visible, the effect is accumulative. In the center, where more circles are layered atop each other, the white is deeper than on the edges where fewer circles are overlaid.

Figure 2.8

Circles within circles, a loop within a loop

Figure 2.9

By not clearing the frame every time you redraw, you can create subtle fades using alpha values.

2.4.3 For loops

There is one final loop to show you before we can go boil the kettle. The **for** loop is used when you want to iterate through a set number of steps, rather than just wait for a condition to be satisfied. The syntax is as follows:

```
for ([initial state]; [end condition]; [step]) {
    code to be executed
}
```

An example is probably the best way to see how this works. Open a new script, and enter the following:

```
void setup() {
  size(500, 300);
  background(180);
  strokeWeight(4);
  strokeCap(SQUARE);
  for (int h = 10; h <= (height - 15); h+=10) {
    stroke(0, 255-h);
    line(10, h, width - 20, h);
    stroke(255, h);/
    line(10, h+4, width - 20, h+4);
  }
}
```

Square edges on lines

No frame loop this time, just a single block of code. The initial state of the **for** loop sets a variable **h** to 10. The code in the loop executes until **h <= (height–15)** (the end condition). Every time the loop is executed, the value of **h** increases by 10, according to the step you've defined (**h += 10**). This means the code inside the parentheses of the for loop will execute 28 times, with **h** set to 10, 20, 30 … 270, 280.

Knowing that the **h** variable follows this pattern, you can use it in multiple ways. The lines you're drawing are in 10-pixel steps down the canvas, because you use **h** for the y value. But the alpha transparency of the lines also varies as **h** varies: the black line gets lighter, and the white line gets darker (see figure 2.10).

You can also terminate loops from within the code block using the **break;** keyword. For example, if you wish to stop your loop as soon as the black line is entirely invisible (and the white line is fully visible), place the following line inside the loop:

```
if (h > 255) { break; }
```

Figure 2.10
Demonstrating the **for** loop in action

Okay new programmers, you now have a fistful of new concepts to get your heads around. There are a few more to come in later chapters, but these are the essential ones. Master these few, and you'll have all the necessary skills to call yourself a coder and be able to hold your corner at a very boring dinner party.

Plenty more programming concepts may be new to you in the remaining chapters of this book, but we won't dwell on them quite as long as we have here. If you're still struggling to get your head around the logic of the procedural processing of instructions, I suggest that you take the time to experiment with the small set of concepts introduced in this section, and also make use of the many great free resources at Processing.org (in particular, the code examples in the Learning section).

Next, we'll look at what you can do with your creations after you've finished coding them.

2.5 Saving, publishing, and distributing your work

The simplified syntax of Processing is perhaps its chief advantage, particularly for the amateur programmer; it greatly reduces the learning curve. But *Processing* also makes it significantly easier to publish your work and share it with the world.

Before you publish your work you should save it. Save, if you haven't already worked it out, is the fifth button on the toolbar (see figure 2.11)—the down arrow. When you first save a script, a folder is created with the name you provide in the dialog box. Your script is saved as a text file in this folder, sharing the same name, with the extension .pde appended. The reason for the folder is to keep things neat when you begin importing and exporting.

Figure 2.11
The toolbar

You'll notice that when loading and saving, Processing uses the term *sketch* to refer to the bundle of scripts and resources that go into a folder. I presume this is to increase the artist appeal, but I think the metaphor becomes rather limiting after a while. You'll have to pardon me if I continue to refer to the text files as *scripts* and the bundle as the *script folder*. This way, you won't end up sounding like an idiot if you ever find yourself having a conversation about similar concepts in some other programming language.

Once you have your script folder, you can free your pixels from the confines of the local output window in a number of ways. The first to try is clicking the Export button (the far-right arrow on the toolbar). Doing so creates a folder called applet within your script folder, containing everything needed to run the sketch in a web browser (see figure 2.12). If you launch the index. html file in a browser, there's your creation, ready to be uploaded to the web (if that is what you want to do with it).

Figure 2.12
The script folder (sketch), containing the script (.pde) and an exported applet folder

> **Warning: Java and the web**
>
> In order for your applet to run in a user's browser, a recent version of Java must be installed. Java in the web browser doesn't have the ubiquity of something like Flash, and the user isn't prompted for automatic upgrades to their Java if their installation is out of date. Publishing Java to the web is often fraught with cross-browser difficulties.

To generate applications to run on the desktop, choose File > Export Application. This enables you to create standalone applications for OS X, Linux, and Windows, or all three at once. Again, the folder containing all you need for these installations is placed in your script folder.

2.5.1 Version control

Having shown you the handy Save button on the toolbar, I'm now going to advise you to stop using it immediately. A much more useful feature is available for organizing your work: Save As, which you can only access via the File menu (or using the keyboard shortcut Apple-Shift-S on the Mac). If you get into the habit of using Save As instead of just hitting Save, you'll be prompted for a name every time you save. You can increment this name—HelloWorld_1, HelloWorld_2, and so on—leaving a version trail as you code.

This technique is called *version control*, and it's useful to have in place to protect your work (it means you can always roll back to an earlier version). But it's also useful for psychological reasons. If your work has a trail of iterations, it frees you to make more sweeping changes to your code, to take new directions, or to try stupid ideas, without worrying about doing anything catastrophic.

This will, imperceptibly, make your coding bolder and more confident, in the same way that when you drive a bumper car at an amusement park, you feel safe knowing that no one is really going to get hurt no matter how crazily you yank the wheel. You tend to drive more recklessly than you would the family sedan.

This practice also enables you to revisit interesting accidents or follow strange tangents. There is little overhead to saving multiple versions; the scripts are just text files (rarely more than a few KB), so they won't fill up your disk.

This amazing feature may seem blindingly obvious to anyone new to coding, but you'd be surprised how this isn't always easy to do in some other more sophisticated programming languages (usually because there are often many files with multiple dependencies upon each

other). This is partly why different languages can have such different flavors. Some encourage a methodical, structured approach; while others, such as Processing (in its native PDE form, anyway), are more attuned to creative flurries.

2.5.2 Creating stills

The final destination of a generative art project isn't always an application or animation, nor may it be intended for the computer screen—in which case you'll be interested in other forms of output.

Capturing still images from an application is relatively straightforward. You can export screenshots of the output window in a variety of formats as the application runs. If you put the following function into your code, it captures a snap at that point and saves it in your script folder:

```
saveFrame("screen-####.jpg");
```

The **####** is replaced with the current frame number when the file is saved, to ensure that Processing doesn't replace the image every frame. If you want to save as .png, .tif, or .tga, these formats are supported; you just need to change the extension in the filename parameter. You can also add folder paths to the URL.

If you place a **saveFrame** function in the **draw()** frame loop and use the hash syntax for your filename, you'll fill your script folder with a succession of sequentially named image files. If it's just a single image you're after, you'll end up with a folder full of imagery that you'll need to sort through at some stage; so you may want to consider writing a conditional (an **if** statement) to snap an image only if certain criteria are met. It will likely require some pretty complicated logic for the machine to determine a good shot from a bad one, so the best way to capture the perfect still is probably to rely on your own eye instead. Include this function within your code:

```
void keyPressed() {
  if (keyCode == ENTER) {
    saveFrame("screen-####.jpg");
  }
}
```

The **keyPressed()** function is a built-in event function, called whenever a key is pressed. The previous function checks whether the key pressed is Enter and, if so, takes a snapshot and saves it in the script folder.

2.5.3 Using a still as an alt image

If you're creating work for the web, here is a useful tip. You may have noticed in figure 2.12 that when you export an applet, it includes a loading.gif image file, which the browser displays while the application is loading or if it fails to load. If a user's Java is incompatible, the loading image may be all they see; so a nice touch when delivering your works to the web is to replace this loading image with a still of the work that is loading. You do this by modifying the generated index.html file. Look for this line:

```
<param name="image" value="loading.gif" />
```

If you replace loading.gif with a reference to your own image, it provides a failsafe for users whose browser isn't capable of running the Java application. At least they'll see a still of your work, even if they can't see it in action.

Next up: the moving image as an output format.

2.5.4 Creating video

A **saveFrame** function within the **draw()** loop creates a folder full of screenshots of every frame in a running application. What's more, the image files are numbered sequentially if you use the hash syntax for your filename. This is useful for software such as QuickTime Pro, which can open an image sequence (available from the File menu in QuickTime Pro) to create a movie file.

The joy of creating for video is that you no longer have to worry about processing power and maintaining a smooth frame rate in Processing. Even if you've specified a frame rate using the **frameRate** parameter, the sketch will only run as fast as your machine allows. If you've overloaded it with some processor-heavy fractal-generation algorithms (which you will in part 3 of this book, believe me), a running application can still crawl. But if you export each frame as an image, to use video as your final medium, you have to take frame rate into account only when you build the movie from the image sequence. The movie will run as fast as you tell it, even if the image sequence it was generated from took many hours to create.

It's common, when creating work for video, to leave a dedicated machine rendering frames overnight, and only see the result when you import the generated frames into your movie maker the next day. Obviously, this removes the immediacy of feedback that you've become used to when working with software, and you can start to get an appreciation for the computer scientists of previous generations who coped with programming via punched cards and mainframe computers. For more complicated movies, you'll probably find yourself developing a system

of working with *wireframes*—simplified or abstracted versions of the finished piece—while you develop, and only upping values/reenabling textures/knitting together features when you run a render.

If you don't have (the incredibly useful) QuickTime Pro or a similar application capable of sequencing images into a movie, Processing can create QuickTime movies from within your code using the Video library, which also enables the use of a webcam as an input device. We won't be covering the huge range of available Processing libraries in these pages, as it's a topic worthy of a book in itself, but they aren't difficult to use. You can explore the functions provided by the Video library at www.processing.org/reference/libraries/video/.

2.5.5 Frame rates and screen sizes

Processing snaps frames at whatever size you've specified for the stage, so a movie can be any dimension. Similarly, the frame rate you specify when importing the sequence is usually arbitrary. But there exist various standards that are used for the web and broadcast media.

When it comes to frame rates, 25 fps (frames per second) is the most common for work intended to be viewed on computer monitors or TVs, although 24 fps and 30 fps are also used in the US (this is the main difference between the 24 fps NTSC format of video that is standard in the US, and 25 fps PAL/SECAM used elsewhere). HDTVs use higher frame rates of 50 or 60 fps because it's been proposed that somewhere around the 50-60 fps mark is the limit of *flicker-fusion*— the point where the human eye can't tell it's watching frames. If you imagine a movie as being alternating black and white frames, at frame rates below 50-60 fps, a person would see it as a flicker; above this limit, it would be seen as grey. This said, a certain amount of lo-fi flicker isn't prohibitively uneasy on the eyes, and an animation can still look smooth at a frame rate of 12 or so.

With screen dimensions, a widescreen format is the most common, usually a 16:9 ratio (such as 1024 x 768 or 1280 x 720). The best practice, though, is to consider where you may want to show your video, and aim for that. Projecting a work onto the wall of an art gallery will doubtless require a different screen ratio than a work designed for mobile phone.

If you're creating video for the web, screen, or TV, the 16:9 standard is pretty ubiquitous. YouTube, for example, currently recommends 1920 x 1080 or 1280 x 720. If you don't use the 16:9 ratio when you upload to YouTube, black borders are automatically added to your movie, padding it to fit. Vimeo isn't too dissimilar, currently supporting 640 x 480 standard definition, 853 x 480 widescreen DV, and 1280 x 720 HD.

2.5.6 Mobile devices, iPhone/iPad, and Android

Processing, as you've discovered, is based on Java. Most modern mobile phones run Java. Does this mean you can create mobile-phone applications in Processing? The answer is yes. Kinda.

If you wish to develop for devices that use Google's Android operating system, it couldn't be simpler. Processing enables you to publish sketches to an Android emulator or an attached device as easily as you can export them to the desktop. The 1.5 release of the Processing IDE added a new button to the toolbar, which toggles the view between "Standard" and "Android". If you select Android Mode, the run and export functionality will be overridden to target a device. You will need to have the Android SDK installed on your machine to use this though. Full instructions on how to set this up are at http://wiki.processing.org/w/Android. There are also two great tutorials on creativeapplications.net that talk through the creation of your first Android app[2] and publishing it for the Android Market[3], by Jer Thorp and Jerome Saint-Clair respectively.

If you're targeting a wider range of devices, including older mobile phones, Processing also has this capability, but it's not as fully featured as the Android route. The Java that most current mobile phones run is special flavor called Java Micro Edition (Java ME), which means there is a special flavor of Processing too to go with it. Mobile Processing isn't a library but an entirely separate application. It has a stripped-down subset of Processing's functions but includes extra functions for dealing with touchscreen interaction, memory management, and other functionality that's specifically relevant to mobiles. It has a similar IDE, but you also need to download a wireless toolkit (WTK)—basically, a phone emulator—to develop for these very particular mini platforms.

I won't go into further details here but will only say that, yes, if mobile is a platform you want to target, the majority of the material in this book can be applied to Mobile Processing as easily as it can Processing. To get started, you can download the IDE and WTK from http://mobile.processing.org/download/. As with Processing, the project is well supported, and a number of tutorials and a reference are available on the site to get you started.

The iPhone and iPad though, are a different matter. When the iPhone was launched in the UK, the Advertising Standards Authority banned an Apple advertisement that claimed the iPhone gave you access to "all the internet," on the basis that if a device doesn't run Java or Flash, it can't really claim to cover "all the internet." At the time of writing, neither Java nor Flash runs on the iPhone, either natively or in the web browser. To develop for Apple platforms, you need to learn Objective-C and be prepared to pay to publish through Apple's App Store.

2. http://www.creativeapplications.net/android/mobile-app-development-processing-android-tutorial/

3. http://www.creativeapplications.net/android/from-processing-to-the-android-market-tutorial/

This situation may, I hope, change over time. Small steps are already being made. But at the time of writing, the huge success of the iPhone, iPad, and the App Store doesn't really put any pressure on Apple to encourage development using other technologies. Recent versions of Flash include a compiler to create iPhone apps, even though Apple's Terms and Conditions prohibit its use. There is also a comparable, and promising, initiative for Processing, called iProcessing. But non-native conversions from one language to another will never compete with native Objective-C applications in terms of performance.

If you want a quick way to see your Processing sketches on your iPhone, there is one beautifully crazy solution. I've already mentioned Processing.js, the JavaScript port of Processing. It's quite a little marvel. It uses HTML5's **Canvas** element to draw shapes directly in the web browser. Like Mobile Processing, it supports only a subset of Processing functions, but it has the added power of being able to mix JavaScript and Processing code together (they're similar in syntax).

You can find the download and introduction to Processing.js at www.processingjs.org/. It exists as a few hundred lines of JavaScript that you include in a webpage. You'll need a little experience with using JavaScript within HTML to get it working in your own web pages; but if you aren't blessed with such skills, you can get straight into Processing.js via HasCanvas, an online interface developed by Robert O'Rourke. It enables you to program direct to the HTML5 **Canvas** tag in real time. You can find it here: www.hascanvas.com/. Anything you create using Processing.js can be seen just about anywhere you can view the web, including your favorite irritatingly proprietary but highly fashionable devices.

2.6 Summary

This brings you to the end of your introduction to Processing. You now have a tool grasped firmly in your eager little fists and are ready for some creative coding. You have the basics of programmatic drawing and a variety of options for media in which to publish—web, print, video, or mobile device. You've also learned a set of programming principles that will serve you well with *any* programming languages, not just Processing.

Next, we'll bring the focus back to how you create art in the generative style. In chapter 3, we'll look at randomness, noise, and the ways you might go about shrugging off the precise computer way of doing things and allow the pen to slip from your fingers a little.

If people do not believe
 that mathematics is simple,
it is only because they do not realize
 how complicated life is.

John von Neumann, speaking in 1947

3

The Wrong Way
to Draw a Line

If there is one thing computers excel at, it's following instructions with a high degree of accuracy. This is partly why they have revolutionized design, architecture, manufacturing, the sciences, and countless other fields.

But precision is of only limited interest to us in the context of generative art. There is a certain joylessness in perfect accuracy; the natural world isn't like that. If our art were to achieve such perfection, it might be dismissed as overly mechanical.

Obversely, although we may crave forms with imperfection and unpredictability, we don't want that imperfection to wander too far into indistinction, either. We're looking for the sweet spot: that balance between the organic and the mechanical, between chaos and order. To find this, we may need to move away from the efficient, programmatic way of drawing lines and nudge the process toward something a little less deterministic.

In this chapter (and the next), I'll explain and demonstrate a core principle behind my particular approach to programmatic art: breaking down even the simplest of processes, and allowing a touch of chaos to creep in. The "right" way to draw a line, according to a machine, is always the most efficient and accurate way of getting from point A to point B. But from an artistic standpoint, it's the "wrong" way that is the often the most interesting.

3.1 Randomness and not-so-randomness

It may be argued that all generative art has to include a degree of randomness; without randomness, there can be no unpredictability, can there? This isn't strictly true. A call to a random-number-generating function isn't always necessary in order to come up with something that appears unpredictable to our limited human calculating faculties. Mathematical formulae above a certain degree of sophistication always return predictable results, yes, but the result may only be predictable to another calculating device of comparable sophistication. It may be beyond what a human observer can project.

Almost all programming languages include a function equivalent to Processing's **random** function, but returning a truly random number is an impossibility for a predictable machine. Computer-generated randomness is always *pseudo-random*, using mathematical formulae, often including a reference to the machine's internal clock as one of its factors to ensure that no two calculations give the same result. The formulae behind these functions are an art in themselves, but you need only trust that a returned random value will be good enough to fool us dumb humans.

I may make light of the topic, but pseudo-randomness is a significant problem in computer science, mainly because of its use in data encryption. If you want to get really anally retentive about your randomness, you'll love the random.org project run by Dublin Trinity College's School of Computer Science. It has an online API for returning "true" random numbers based on atmospheric noise. But this only moves the debate into the realm of chaos math and the questionable quantum predictability or unpredictability of the natural world.

Using **random** is simple. A random function typically returns a value in the range 0 to 1, which you can then manipulate to give a value within any given range. In Processing, you pass a parameter to give a maximum value, or two parameters to return a number within a range. For example, if you want a number in the range 20 to 480, you can use

```
float randnum = random(460) + 20;
```

Or you can also write it like this:

```
float randnum = random(20, 480);
```

I prefer the first notation, even though the range is less obvious upon reading. Later in this chapter, you'll use functions that can only return values between 0 and 1; you won't have the convenience of passing a range to them, which is why I force myself to get used to thinking of variance without Processing's more convenient convention. Without using any parameters, you can express any random range as follows:

```
float randnum = (random(1) * (max+min)) – min;
```

Let's apply this to the drawing of a line. If a line is what you're after, there is an easy way to connect point A to point B (see figure 3.1):

Figure 3.1
The correct way to draw a line

```
size(500,100);
background(255);
strokeWeight(5);
smooth();

stroke(20, 50, 70);
line(20,50,480,50);
```

Randomizing the line is then just a matter of replacing the parameters. Note how you use the **width** and **height** constants, even though you know the width is 500 and the height is 100. It means the script will adapt to these relative values if you decide to change **width** or **height** later. Even if you have no intention of doing such a thing, it's a good habit to get into:

```
stroke(0, 30);
line(20,50,480,50);

stroke(20, 50, 70);
float randx = random(width);
float randy = random(height);
line(20,50,randx, randy);
```

Figure 3.2

A rather uninteresting random line

Figure 3.2 shows a possible output. Without wanting to be too judgmental of your first piece of generative drawing, this is rather uninteresting. It's just not doing it for me I'm afraid. Still the line is too controlled, too tightly gripped by the machine's way of drawing. To overcome this, we need to take a step back from the language's useful conveniences and deconstruct it a little.

3.2 Iterative variance

We know the computer is capable of getting from point A to B with maximum efficiency, but efficiency isn't necessarily useful aesthetically. To make things more interesting, we need to take a step back from the "best" way of drawing a line and look at some less optimal options. You could start by breaking the line-drawing process into a series of steps.

The following code chunk uses a **for** loop to iterate through the x position in 10-pixel steps, keeping track of the last x and y positions so it can draw a micro-line back to the previous point. The line is constructed as a chain of 46 links. The resulting image in the output window will look exactly the same as that shown in figure 3.1: a line from point 20,50 to 480,20. But you're now using a few more lines of code:

```
int step = 10;
float lastx = -999;
float lasty = -999;
float y = 50;
int border = 20;
for (int x=border; x<=width-border; x+=step) {
  if (lastx > -999) {
    line(x, y, lastx, lasty);
  }
  lastx = x;
  lasty = y;
}
```

If this were an old lady you were helping across the road, and you insisted on instructing her every footstep—"Now move your left foot a few centimeters, then your right …"—she'd probably think you were crazy, and be checking her purse. But it's impossible to patronize a computer program. Believe me, I've tried. Pointless, tedious, and seemingly arbitrary instructions are perfectly fine and won't be criticized. Our machines are capable of carrying out dumb instructions as smoothly and efficiently as they would execute "good" code.

This staccato drawing style enables you to start adding a more interesting flavor of randomness to your line. Add an instruction to vary the **y** value with every step:

```
int step = 10;
float lastx = -999;
float lasty = -999;
float y = 50;
int borderx=20;
int bordery=10;
for (int x=borderx; x<=width-borderx; x+=step) {
  y = bordery + random(height - 2*bordery);
  if (lastx > -999) {
    line(x, y, lastx, lasty);
  }
  lastx = x;
  lasty = y;
}
```

The first line in the loop assigns **y** a random value between 10 and 90. The result is shown in figure 3.3.

Figure 3.3
Introducing randomness to the y position

How easily the line develops an unpredictability. The line will be different every time you run the script. But perhaps you've wandered too far in the direction of chaos. Let's pull back on the randomness reins a little. In the following example, instead of just making the y position random in a range, you add or subtract a random amount from the previous **y** value, creating a more natural variance:

```
float xstep = 10;
float ystep = 10;
float lastx = 20;
float lasty = 50;
float y = 50;
for (int x=20; x<=480; x+=xstep) {
  ystep = random(20) - 10;  //range -10 to 10
  y += ystep;
  line(x, y, lastx, lasty);
  lastx = x;
  lasty = y;
}
```

The result is shown in figure 3.4.

This is starting to look better. Yes, a raggedy line is what I'm calling "better" in this context: the line is less controlled, yet not so chaotic as to be useless.

You've drawn only a single line so far, but already you can see a touch of the analogue creeping into the output. You can refine this further to get a gentler progression, or dive in and start drawing more shapes using this method; but first I want to show you a much easier way of giving your lines naturalistic forms. Wherever you can use **random**, you can use **noise**, which is what you'll play with next.

Figure 3.4
Random variance looks better than plain randomness.

3.3 Naturalistic variance

There aren't many programming awards that your mom has heard of. So on the day Ken Perlin bought home an Oscar—an Academy of Motion Picture Arts and Sciences award—for an algorithm he created, I'd imagine it was a rare case of a programmer's mother phoning all her friends and praising his decision to devote his life to communing with the calculating machines.

The Technical Achievement Oscar that Ken was (rather belatedly) awarded in 1997 was for his work on procedural textures developed while working on the graphics for the science fiction film *TRON* (1982). *TRON* was a pioneering movie in both subject matter and production. It made a hero of a video gamer at a time when video games were seen as an idiotic frivolity; and much of the film took place in virtual reality, two years before William Gibson's *Neuromancer* was credited with popularizing the concept of cyberspace. Most significantly, though, it was one of the first films to rely heavily on computer graphics for its special effects.

Ken's job was to develop textures to give 3D objects a more natural appearance. He was looking for ways to generate randomness in a controlled fashion, much like we were in the previous section. The function he came up with to do this, his *Perlin noise*, is really just another pseudo-random function—but it's a bloody good one, one specifically attuned to natural-looking visuals. If you're interested in the logic behind it, you can view the code, along with examples of Ken's applications of it, on his website: http://mrl.nyu.edu/~perlin/.

By the late 1980s, Ken Perlin's noise functions were pretty much ubiquitous. It's probably safe to say that if you've ever played a graphical console game, or seen a computer-animated film, or seen CGI used in any movie made in the last 20 years, you've seen Ken's work in action. Now, with Processing, Ken's algorithms are encapsulated into a simple function—**noise**—that enables you to harness in your own creations the same naturalistic variance seen on the big screen.

3.3.1 Perlin noise in Processing

noise is generally used to produce a sequence of numbers. You pass it a series of seed values, each of which returns a noise value between 0 and 1 calculated according to the values that precede and follow it. It doesn't matter where you start the sequence of values, but it's a good idea to randomize the start point; otherwise, the resulting line will be identical every time. Small increments, between 0 and 0.1, usually give the best results.

Figure 3.5

Perlin noise: a possible output of listing 3.1

Figure 3.6

Perlin noise, with **ynoise** increment of 0.03 for every x pixel

Probably the best way to get an appreciation of **noise** is to try using it. Listing 3.1 takes the script from the last section and replaces the call to **random** with a **noise** sequence.

Listing 3.1 **Perlin noise**

```
size(500,100);
background(255);
strokeWeight(5);
smooth();

stroke(0, 30);
line(20,50,480,50);

stroke(20, 50, 70);
int step = 10;
float lastx = -999;
float lasty = -999;
float ynoise = random(10);
float y;
for (int x=20; x<=480; x+=step) {
  y = 10 + noise(ynoise) * 80;
  if (lastx > -999) {
    line(x, y, lastx, lasty);
  }
  lastx = x;
  lasty = y;
  ynoise += 0.1;
}
```

Between 10 and 90

In this example, the sequence of values starts somewhere between 0 and 10 (**random(10)**) and increments by 0.1 every step of the loop. The call to **noise()** for every seed value in the sequence returns a floating-point number between 0 and 1, which you adapt (multiply by 80, add 10) to produce a useful **y** value between 10 and 90. The result (one possible result, anyway) is shown in figure 3.5.

For a smoother result, you can reduce the **x** step to 1, so the line steps only one pixel at a time horizontally; reduce the **ynoise** step accordingly. Figure 3.6 shows a single-pixel x step with **ynoise** steps of 0.03.

It's a handy trick. But don't think Ken Perlin is the only person who can write an interesting variance function.

Generative Art | Pearson

3.3.2 Creating your own noise

As mentioned at the start of this chapter, when you call a function such as **noise** or **random,** you aren't plucking a value from the ether; the function returns the result of a calculation. The calculation may be deliberately abstract, as in the case of **random**—so abstract as to appear utterly unpredictable (although, obviously, it *is* predictable if you know the formula), but it's still just a calculation. I don't want you to think these are the only calculations you can use to spice up the drawing of a line. You have the whole world of mathematics to explore.

Let's start with a few easy formulas. Like **noise,** the trigonometric functions **sin** and **cos** also return values that vary smoothly according to arguments you pass to them. With these two mathematical functions, you pass an angle (in radians), and the functions return a value between -1 and 1.

To visualize this, let's reapproach the straight line once more, using some mathematics of a distinctly smoother flavor. Try listing 3.2.

Listing 3.2 Drawing a sine curve

```
float xstep = 1;
float lastx = -999;
float lasty = -999;
float angle = 0;
float y = 50;
for (int x=20; x<=480; x+=xstep) {
  float rad = radians(angle);
  y = 50 + (sin(rad) * 40);
  if (lastx > -999) {
    line(x, y, lastx, lasty);
  }
  lastx = x;
  lasty = y;
  angle++;
}
```

sin returns -1 to +1

This code produces the curve shown in figure 3.7.

If you replace **sin** with a cosine function (see figure 3.8), the result is similar. Sine and cosine are used to calculate the points around a circle (more of that in the next chapter), so it's unsurprising that the values they return are a nice smooth variance.

Figure 3.7
A sine curve

Figure 3.8
A cosine curve. Not too dissimilar from a sine curve.

Figure 3.9

A line constructed from the return values of **sin** cubed

Figure 3.10

sin cubed, with a soupçon of **noise**

Figure 3.11

The **customRandom** function in action. It isn't quite as random as **random**.

Having set out to experiment with chaos, this smooth predictability may seem useless. But that's only because the calculation is too simple. It doesn't take many degrees of abstraction before it starts looking like the unpredictability of a **random** or **noise** function.

How does it look if you cube **sin** (see figure 3.9)?

```
y = 50 + (pow(sin(rad), 3) * 30);
```

Or, how about if you add a bit of **noise** too (see figure 3.10)? Is that cheating?

```
y = 50 + (pow(sin(rad), 3) * noise(rad*2) * 30);
```

This is the basic principle: by mixing up a few mathematical transformations, you can start to get interesting and unique lines. Let's put this principle into action.

3.3.3 A custom random function

The problem with **random,** as you've discovered, is that it's just too damn random. Perhaps if you can transform the randomness into something a little more predictable, it may have more aesthetic value.

First, let's create a custom function:

```
float customRandom() {
  float retValue = 1 - pow(random(1), 5);
  return retValue;
}
```

Then, use this function where you calculate the y position:

```
y = 20 + (customRandom() * 60);
```

What you've done with this function is raise the random number to the power of five (see figure 3.11). If you were to square the random number, you'd get a returned value that tended more toward 0. If you were to raise it to the power of a half, the number would tend toward 1. Taking it further, raising it to the power of 5 (or, in the other direction, 0.1 as another example), you get a range of random results that are, well, less random.

You can experiment further with other transformations within this function. You can even rewrite it so it doesn't use the **random** function at all—instead, come up with a calculation so convoluted that it appears random, the same way other pseudo-random functions work.

3.4 Summary

All we've done in this chapter is look at various different ways of drawing a single line: leaving behind the convenience of Processing's built-in **line** function, and discovering more interesting possibilities by iterating through the line a pixel at a time. Through this mechanism, you can add some attractive flavors of variance, freeing your line from its mechanical perfection.

In the next chapter, having mastered the art of messing up a simple job like drawing a straight line, you'll apply this technique to something a little more substantial. Prepare yourself to rediscover the joys of trigonometry, as we look at that simplest of shapes, the circle.

4

The Wrong Way to Draw a Circle

To most, *trigonometry* is a scary word. I'll be the first to confess that it utterly bewildered me at school. I remember thinking to myself that I would *never* use this crap in the real world. And I was right—for a couple of years at least.

Until sometime in my late twenties, I found myself making Flash games for a living, and more and more I found bits of half-remembered trig proving useful.

In this chapter, we'll play with unconventional ways of drawing circles, for which we'll need a little trig. In the same way we wandered away from the useful convenience of the **line** function in the last chapter, we won't rely on Processing's **ellipse** function here. Instead, by working out the math ourselves, we'll be able to tease out a more nonmechanical, imprecise way of drawing this one shape. Many of my own works have been based on this single idea—rotational drawing algorithms—and so I'll offer one of them as a case study later in the chapter.

4.1 Rotational drawing

It didn't take much googling to discover that, after subjecting my poor adolescent brain to two years of A-level mathematics, all the trig I've ever really needed to know fits quite easily onto the back of a postcard. I scribbled the arcane markings you see in figure 4.1 sometime during my coding adolescence (a period I don't think I've ever really left). I've had this card tucked into a book in my office for more than 10 years now, and I've never needed much more (although the book it's tucked into has changed many times).

We'll use a little of that trig now, as in the same way we deconstructed the drawing of a line, we vandalize the circle.

Figure 4.1
All the trig I've ever needed fits on the back of a postcard.

4.1.1 Drawing your first circle

Let's start with the easy way of drawing a circle:

```
ellipse(x, y, diameter, diameter);
```

All you need for this method is a center point, width, and height, width and height both being equal to the diameter when you're drawing a circle. But there is a lot more fun to be had if you break it down a little. To do so, you'll use two equations from my postcard cheat-sheet: sin x = opp/hyp, and cos x = adj/hyp. The sine of angle x is equal to the opposite over the hypotenuse. The cosine of angle x is equal to the adjacent over the hypotenuse.

Knowing the center point of the circle, the hypotenuse between the center and a point on the circumference is the radius. The opposite and adjacent then correspond to the difference in x and y positions from the center point. By jigging the equations, you can calculate the coordinates of any point on the circumference of a circle relative to the angle as follows:

```
X = centerX + (radius * cos(angle));
Y = centerY + (radius * sin(angle));
```

Figure 4.2 shows the circle drawn using the code in listing 4.1. To highlight the math in action, I've marked the steps of the loop as points.

To complete the circle, you would draw lines connecting these points. Increments of 5 degrees are smooth enough for this example, but you can decrease this increment later if you want.

Figure 4.2

Drawing a circle using trigonometry: the output of listing 4.1

Radians and degrees

Angles used by trigonometric functions are in radians, not degrees. One radian is equal to 180/π, so a full revolution of a circle (360 degrees) is 2π radians. If you aren't comfortable with radians, you can work in degrees and convert before calling a trigonometric function. The formula is on my postcard: *radian = degrees* * (180/π), but Processing has two handy conversion functions already built in - **degrees** and **radians**.

Listing 4.1 Drawing a circle: first the easy way, then using trigonometry

```
size(500,300);
background(255);
strokeWeight(5);
smooth();

float radius = 100;
int centX = 250;
int centY = 150;

stroke(0, 30);
noFill();
ellipse(centX,centY,radius*2,radius*2);

stroke(20, 50, 70);
float x, y;
float lastx = -999;
float lasty = -999;
for (float ang = 0; ang <= 360; ang += 5) {
  float rad = radians(ang);
  x = centX + (radius * cos(rad));
  y = centY + (radius * sin(rad));
  point(x,y);
}
```

360-degree loop

Converts from degrees to radians

That's all you need. That's as hard as the trig is going to get within these pages. You now have a systematic way of drawing a circle; the next job is to begin tweaking it into something less rigid.

Figure 4.3
A few minor tweaks, and the circle becomes a spiral.

4.1.2 Turning a circle into a spiral

Now that you have greater control over the drawing, you can perform tricks like turning a circle into a spiral. To do so, you simply increase the radius as the angle turns. Note that you'll need to turn more than just 360 degrees, though. The required changes to the code are highlighted in the following listing, and the output is shown in figure 4.3.

Listing 4.2 Code changes required to turn a circle into a spiral

```
radius = 10;
float x, y;
float lastx = -999;
float lasty = -999;
for (float ang = 0; ang <= 1440; ang += 5) {
  radius += 0.5;
  float rad = radians(ang);
  x = centX + (radius * cos(rad));
  y = centY + (radius * sin(rad));
  if (lastx > -999) {
    line(x,y,lastx,lasty);
  }
  lastx = x;
  lasty = y;
}
```

Starts small

Loops four times

So far, so boring. Let's add some noise.

4.1.3 Noisy spirals

Listing 4.3 increments the radius as before but also varies it by a rather large noise factor. A possible output is shown in figure 4.4.

Listing 4.3 Adding noise to the spiral

```
radius = 10;
float x, y;
float lastx = -999;
float lasty = -999;
float radiusNoise = random(10);
for (float ang = 0; ang <= 1440; ang += 5) {
  radiusNoise += 0.05;
```

(continued on next page)

Figure 4.4

The spiral, with noise. Is that a butterfly in the middle there?

Figure 4.5

The spiral code turned up to 11

```
radius += 0.5;                                                                    (Listing 4.3 continued)
float thisRadius = radius + (noise(radiusNoise) * 200) – 100;
float rad = radians(ang);
x = centX + (thisRadius * cos(rad));
y = centY + (thisRadius * sin(rad));
if (lastx > -999) {
  line(x,y,lastx,lasty);
}
lastx = x;
lasty = y;
}
```

I hope you agree that by the time you've reached this stage, you're starting to see something interesting emerging—something you might call *generative*. These shapes have a basis in mathematical seeds you've programmed, but there is enough randomness about the way they're drawn that they're taking on a form of their own.

The next step—and I firmly believe that, if in doubt, this should *always* be your next step—is to multiply it all by 100 (see figure 4.5).

In this version, you use a **for** loop to draw the same spiral 100 times. You also lighten the line weight; and for each spiral, you randomize the stroke color, the alpha, the starting angle, the end angle, and the angle step. The full code is in the following listing.

Listing 4.4 100 spirals, with noise

```
size(500,300);
background(255);
strokeWeight(0.5);                                                                 Finer line
smooth();

int centX = 250;
int centY = 150;

float x, y;
for (int i = 0; i<100; i++) {                                                       Draws 100 spirals
  float lastx = -999;
  float lasty = -999;
  float radiusNoise = random(10);
  float radius = 10;                                          (continued on next page)
```

(Listing 4.4 continued)

```
                                        stroke(random(20), random(50), random(70), 80);

Randomizes
spiral aspects                          int startangle = int(random(360));
                                        int endangle = 1440 + int(random(1440));
                                        int anglestep = 5 + int(random(3));
                                        for (float ang = startangle; ang <= endangle; ang += anglestep) {
                                         radiusNoise += 0.05;
                                         radius += 0.5;
                                         float thisRadius = radius + (noise(radiusNoise) * 200) - 100;
                                         float rad = radians(ang);
                                         x = centX + (thisRadius * cos(rad));
                                         y = centY + (thisRadius * sin(rad));
                                         if (lastx > -999) {
                                          line(x,y,lastx,lasty);
                                         }
                                         lastx = x;
                                         lasty = y;
                                        }
                                       }
```

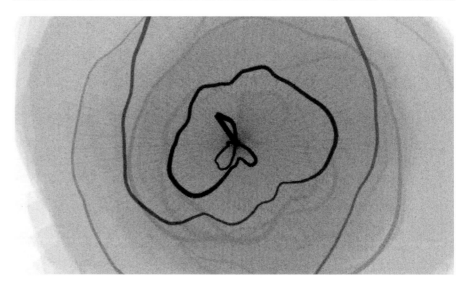

Figure 4.6
Spiral Stairs (2009)

It's a mess, but it's an interesting mess. I wouldn't print this on a greeting card quite yet, but it's a start. I *do* hope you can see how the application of noise and/or randomness to a systematic drawing process can lead us toward aesthetically interesting results (see figure 4.6, for example).

Through this process of abstracting a mathematically constructed shape, you move the visual from order toward chaos. As long as you don't go too far toward the disordered end of the spectrum, the abstraction stays interesting. And if it's interesting, you can call it art.

4.1.4 Creating your own noise, revisited

To stop you from getting too dependent on Perlin noise, useful though it is, let's try the circle drawing once more, but this time produce your own naturalistic variance. In the last chapter, you created a custom **random** function for the drawing of a line. Now you can take that a step further and adapt that into a custom **noise** function, which calculates a return value according to the seed value it's passed; you can then apply this function to your circle.

To do this, you'll have to organize things a little first. In listing 4.5, you take the circle-drawing code from listing 4.1 and do the following:

- Rewrite it into function blocks.
- Add the **customNoise** function.

Listing 4.5 A circle drawn with a custom noise function

```
void setup () {
  size(500,300);
  background(255);
  strokeWeight(5);
  smooth();

  float radius = 100;
  int centX = 250;
  int centY = 150;

  stroke(0, 30);
  noFill();
  ellipse(centX,centY,radius*2,radius*2);

  stroke(20, 50, 70);
  strokeWeight(1);
```

(continued on next page)

Figure 4.7

The output of listing 4.5: a custom variance to the circumference, based on sine

Figure 4.8

Another custom variance based on powers of sine

Figure 4.9

You can see the source code for this animation at http://abandonedart.org/?p=549.

It uses a simple custom **noise** function much like you've created in this section.

```
float x, y;
float noiseval = random(10);
float radVariance, thisRadius, rad;
beginShape();
fill(20, 50, 70, 50);
for (float ang = 0; ang <= 360; ang += 1) {

  noiseval += 0.1;
  radVariance = 30 * customNoise(noiseval);

  thisRadius = radius + radVariance;
  rad = radians(ang);
  x = centX + (thisRadius * cos(rad));
  y = centY + (thisRadius * sin(rad));

  curveVertex(x,y);
  }
  endShape();
}

float customNoise(float value) {
  float retValue = pow(sin(value), 3);
  return retValue;
}
```

(Listing 4.5 continued)

Randomizes start point

Returns value -1 to +1

You make one other crucial change in listing 4.5. Instead of drawing lines back to the previous point, as you did before, this time you use **beginShape** and **endShape** to draw an enclosed area to which you apply a **fill**. You add points to the shape with **curveVertex(x,y)**. The result is something a little like figure 4.7.

For this first example, **customNoise** returns the value of sine cubed, which gives you a regular repeating variance. Now that you have the structure, you can experiment with the mathematics in your new function. Let's try, for example, using the parameter value to determine the power to which you raise sine:

```
float customNoise(float value) {
  int count = int((value % 12));
  float retValue = pow(sin(value), count);
  return retValue;
}
```

Using this function, you end up with something like figure 4.8.

Okay, it doesn't quite have the beauty of Perlin noise, so I don't think this one will win the Oscar. But you now have a custom variance you can call your own, which you can apply to lines, shapes, movement, or anything else you might apply **noise** to.

The next stage is to continue throwing whatever mathematics you know into the function and seeing what other glorious messes the routine can create (see, for example, figure 4.9). It doesn't matter if your math is poor—you can achieve plenty with just addition, subtraction, multiplication, and division. The complexity of the math doesn't necessarily correspond to the interestingness of the visual. Juggle some numbers, alter the shapes or the drawing style, turn it up to 11, and see if you can surprise yourself.

In the next section, I'll walk you through my process in creating one of my own Perlin noise–based works. There are a thousand creative things you can do with a set of numbers in a naturally varying sequence (we'll look at a few more in the next chapter), but I hope a single practical example at this point will be sufficient to inspire you to apply the techniques of this chapter and the last to your own ideas.

4.2 Case study: *Wave Clock*

My *Wave Clock* (see figure 4.10) is a nice, simple example of using Perlin noise to produce a natural-looking form. I can't say I was working toward any particular goal at the time I fashioned the system, but I can still recount the steps I took so you can gain some appreciation of my process.

I began by plotting a circle, exactly as you did in the previous section, and then drawing a line from each point on the circumference to its opposite point. I calculated the opposite point by adding pi to the current angle, which, if you're using radians, rotates it 180 degrees. I then extrapolated the two circumference points using the same sine and cosine functions:

```
float rad = radians(_angle);

float x1 = centerX + (_radius * cos(rad));
float y1 = centerY + (_radius * sin(rad));

float opprad = rad + PI;
float x2 = centerX + (_radius * cos(opprad));
float y2 = centerY + (_radius * sin(opprad));

line(x1, y1, x2, y2);
```

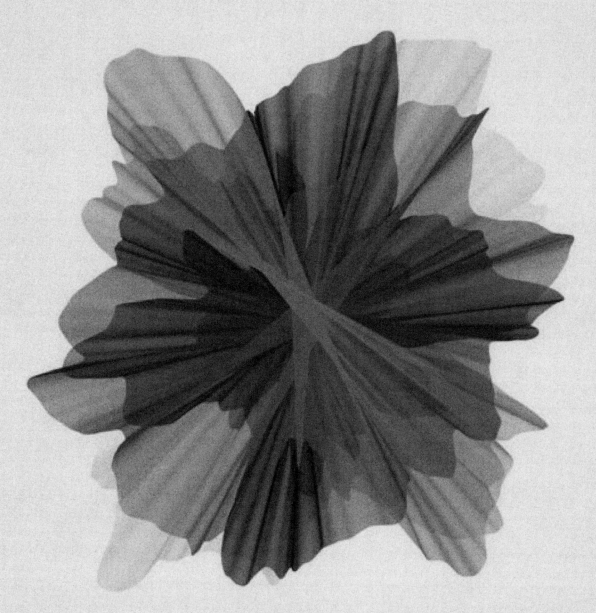

Figure 4.10
Wave Clock (2009)

Figure 4.11

A circle constructed by drawing lines
from a point on the circumference to its opposite edge

Figure 4.12

Fade effect added by incrementing
the stroke color as the line rotates

Figure 4.13

Perlin noise variance added to the radius value

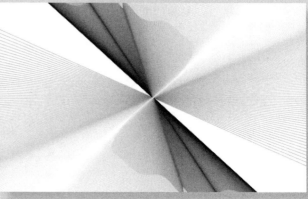

Figure 4.14

Perlin noise variance added to the rotation speed/direction

Figure 4.11 shows the output.

This produced a nice, smooth circle. To give it a fade, I added a few lines to vary the stroke color. I defined a **strokeCol** variable, started it at 255 (white), and decremented it by 1 every frame until it reached 0 (black). Then, I reversed the process back to 255 *ad infinitum*. The result is shown in figure 4.12.

Next, I made the length of the connecting line change by varying the radius with a noise value as it rotated (see figure 4.13).

```
_radiusnoise += 0.005;
_radius = (noise(_radiusnoise) * 550) +1;
```

Then, to give it a further spin, I varied the density of the line packing by adding a second noise variance to the angle of rotation. I allowed the angle to increase or decrease so the rotation could reverse. This gave the effect you can see in figure 4.14:

```
_angnoise += 0.005;
_angle += (noise(_angnoise) * 6) - 3;
if (_angle > 360) { _angle -= 360; }
if (_angle < 0) { _angle += 360; }
```

Finally, for one extra touch of non-linearity, I wobbled the center of the circle slightly, again using a noise function to move it plus or minus 10 pixels in the x or y direction:

```
_xnoise += 0.01;
_ynoise += 0.01;
float centerX = width/2 + (noise(_xnoise) * 100) - 50;
float centerY = height/2 + (noise(_ynoise) * 100) - 50;
```

The final code for this system is in the following listing.

Listing 4.6 Final code for *Wave Clock*

```
float _angnoise, _radiusnoise;
float _xnoise, _ynoise;
float _angle = -PI/2;
float _radius;
float _strokeCol = 254;
int _strokeChange = -1;

void setup() {
```

(continued on next page)

Generative Art | Pearson



```
  size(500, 300);                                                        (Listing 4.6 continued)
  smooth();
  frameRate(30);
  background(255);
  noFill();

  _angnoise = random(10);
  _radiusnoise = random(10);
  _xnoise = random(10);
  _ynoise = random(10);
}

void draw() {

  _radiusnoise += 0.005;
  _radius = (noise(_radiusnoise) * 550) +1;

  _angnoise += 0.005;
  _angle += (noise(_angnoise) * 6) - 3;
  if (_angle > 360) { _angle -= 360; }
  if (_angle < 0) { _angle += 360; }

  _xnoise += 0.01;
  _ynoise += 0.01;
  float centerX = width/2 + (noise(_xnoise) * 100) - 50;
  float centerY = height/2 + (noise(_ynoise) * 100) - 50;

  float rad = radians(_angle);
  float x1 = centerX + (_radius * cos(rad));
  float y1 = centerY + (_radius * sin(rad));

  float opprad = rad + PI;
  float x2 = centerX + (_radius * cos(opprad));
  float y2 = centerY + (_radius * sin(opprad));

  _strokeCol += _strokeChange;
  if (_strokeCol > 254) { _strokeChange = -1; }
  if (_strokeCol < 0) { _strokeChange = 1; }
  stroke(_strokeCol, 60);                                              (continued on next page)
```

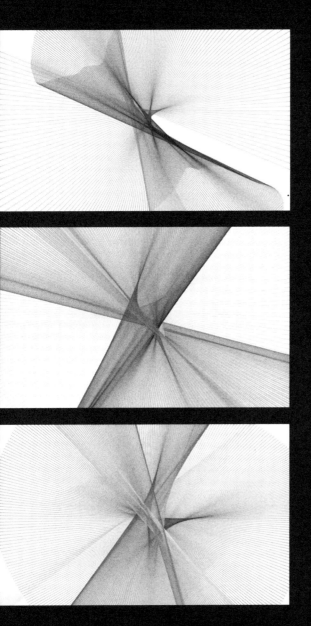

Figure 4.15
Outputs from the completed system: *Wave Clock* (2009)

```
    strokeWeight(1);                                          (Listing 4.6 continued)
    line(x1, y1, x2, y2);
  }
```

Figure 4.15 shows a few possible outputs.

4.2 Summary

In this chapter, we've gone from a wonky way of drawing a line to a complete generative system one that churns out some rather pleasing results. The basic methodology established in these last two chapters is as follows:

• Deconstruct a machine-drawn shape.

• Reconstruct it with some form of unpredictability.

You can apply this simple technique to make just about anything more interesting.

There is plenty of further fun to be had playing with circles—they're one shape it's hard to tire of. But you may now want to try other computer-drawn forms. I'll leave it with you experiment.

In the next chapter, before we move on to even cooler organic methodologies in part 3 of the book, we'll take noise into a few extra dimensions and also see what happens when we use it to manipulate both time and space.

Adding Dimensions

Imagine you're a tiny creature clinging to the surface of a large ball.[1] You walk the surface of that ball for a lifetime, until you feel you've covered every part of its surface and know it intimately. At this stage, it feels as though there is nowhere new for you to go, nothing new to see. That is, until you discover up, and suddenly you find a perspective from which everything looks very different.

Often, we meet barriers like this in our work, when it seems there is nowhere else to take an idea. This is the point at which you should consider adding extra dimensions. If you've been working in one dimension, try it with two. If you're working in two dimensions, try three.

The computer monitor, printed page, or gallery wall has only two dimensions. Anything you create for these media will always be flattened for presentation. But that doesn't mean your work is limited to those dimensions. You've already learned, in chapter 2, how to make your work animate, giving it an extra dimension: time. In this chapter, we'll revisit that idea, as well as learning how Processing renders three-dimensional drawing.

1. This shouldn't be hard to imagine, given that you actually are.

We'll keep Perlin noise as our focus while we examine these concepts, because there is still much more to explore in relation to that subject. So far, you've only used the **noise** function with a single parameter, creating one-dimensional noise. You'll begin by adding an extra dimension to that.

5.1 Two-dimensional noise

Noise in two dimensions isn't much more complicated than it is in one—it's just a matter of shifting perspective, conceptually, from a line to a plane. One-dimensionally, a progression of noise values yields a wavering line, like a mountain range viewed on the horizon. Looking at it in two dimensions, you're viewing the mountain range from above, as if you were flying over it in a helicopter; looking straight down, you see a plane of peaks and troughs.

5.1.1 Creating a noise grid

The best way to demonstrate is with an example. Open a new script, and tap in the contents of the following listing.

Listing 5.1 **A two-dimensional noise grid**

```
size(300,300);
smooth();
background(255);
float xstart = random(10);
float xnoise = xstart;
float ynoise = random(10);

for (int y = 0; y <= height; y+=1) {
    ynoise += 0.01;
    xnoise = xstart;
    for (int x = 0; x <= width; x+=1) {
        xnoise += 0.01;
        int alph = int(noise(xnoise, ynoise) * 255);
        stroke(0, alph);
        line(x,y, x+1, y+1);
    }
}
```

Resets xnoise at start of each row

Noise function takes two values

Figure 5.1
Perlin noise in 2D, visualized as alpha values

In this script, you create a grid of points (except I've used tiny lines instead of points, because in Processing lines are better at alpha values). You loop through the pixels of this 300 by 300 square, traversing column by column, row by row, one pixel at a time. Noise seeds in the x and y direction are incremented by 0.01 with every pixel, remembering to reset the x seed to its original position at the end of each row, like hitting the carriage return on an old typewriter. The return of the **noise** function for each x and y position is visualized as a variance in the alpha values on the tiny line you're drawing at every position. The result is shown in figure 5.1.

The fun with two-dimensional noise is in dreaming up new ways to visualize it, which is what we'll do next.

5.1.2 Noise visualizations

First, knowing that the two-loop traversal through the grid won't change much, you can separate the visualization part into a function block. It will help if you also space the grid out a little, too, so you can see what's going on.

```
float xstart, xnoise, ynoise;

void setup() {
  size(300,300);
  smooth();
  background(255);
  xstart = random(10);
  xnoise = xstart;
  ynoise = random(10);
  for (int y = 0; y <= height; y+=5) {
    ynoise += 0.1;
    xnoise = xstart;
    for (int x = 0; x <= width; x+=5) {
      xnoise += 0.1;
      drawPoint(x, y, noise(xnoise, ynoise));
    }
  }
}

void drawPoint(float x, float y, float noiseFactor) {
  float len = 10 * noiseFactor;
  rect(x, y, len, len);
}
```

Spacing increased;
increase noise steps too

The custom **drawPoint()** function takes three parameters: **x** and **y** to define where the point is, and the two-dimensional **noiseFactor** that has been calculated for that point. In this case, you draw a tiny square, using the noise factor to determine its size. Click run, and you'll be looking at something like figure 5.2.

Now that you've defined the function, you can modify this part to experiment further. How about visualizing the noise as a rotation? Here's a new version of the **drawPoint** function that draws a 20-pixel line rotated according to **noiseFactor**:

```
void drawPoint(float x, float y, float noiseFactor) {
  pushMatrix();
  translate(x,y);
  rotate(noiseFactor * radians(360));
  stroke(0, 150);
  line(0,0,20,0);
```

(continued on next page)

Figure 5.2
2D Perlin noise visualized as squares of varying size

Figure 5.3
2D Perlin noise visualized using rotation

```
popMatrix();
}
```
(continued from previous page)

To perform the rotation, you used **translate(x, y)** to move the drawing position, and then you start the drawing from point 0,0 instead of point (x,y). You do this so the rotation is around the point you're drawing at, not the upper-left 0,0 point. The functions **pushMatrix** and **popMatrix** are a way of storing the previous drawing position before you perform the translation and rotation, and then restoring it afterward. Figure 5.3 shows the result.

Okay, one more. Change **background(255)** to **background(0)** in the **setup** function, and then rewrite **drawPoint** so it varies the rotation, size, color, and alpha, all using the same noise factor:

```
void drawPoint(float x, float y, float noiseFactor) {
  pushMatrix();
  translate(x,y);
  rotate(noiseFactor * radians(540));
  float edgeSize = noiseFactor * 35;
  float grey = 150 + (noiseFactor * 120);
  float alph = 150 + (noiseFactor * 120);
  noStroke();
  fill(grey, alph);
  ellipse(0,0, edgeSize, edgeSize/2);
  popMatrix();
}
```

The resulting grid now looks something like figure 5.4.

Using translate

Imagine you're holding a pen in one hand and steadying a piece of paper with the other. When you give a command like **line(20, 30, 120, 130)**, you're specifying co-ordinates for the pen to move from and to, relative to the origin point (0, 0) in the upper left corner. When you use **translate(20, 30)** you're not commanding the pen, you're instead moving the *paper*. Point (20, 30) becomes the new origin from which to start drawing.

Performing **translate(20, 30)** and then **line(0, 0, 100, 100)** produces the same result as the command **line(20, 30, 120, 130)**, but sometimes it's easier to follow, especially when you begin drawing things relative to each other.

For some actions, such as rotating about a point, you will find it is much easier to do this by moving the paper than it is the pen.

Figure 5.4
2D Perlin noise as little fluffy clouds

You get the gist. I'd suggest that you try throwing a few of your own ideas at this function to see what emerges. Perhaps have a rifle through the Processing reference to come up with different ways of drawing that you haven't tried before, and then see how they can be subverted by applying the noise factor.

Next, we'll look at time as an extra dimension, and see how you can apply noise to that.

5.2 Noisy animation

The *frame loop*, Processing's built-in **draw** function, enables you to create images that change over time. This, folks, is what we call *animation*: you may have heard of it. Refer back to section 2.3.1 if you need a refresher on how the frame loop works. The following listing uses the **draw** function to turn the two-dimensional noise grid into something that moves.

Listing 5.3 Noise grid again, now drawing on the frame loop

```
float xstart, xnoise, ystart, ynoise;

void setup() {
  size(300,300);
```

(continued on next page)

Generative Art | Pearson

```
                                        smooth();                                              (Listing 5.3 continued)
                                        background(0);
Sets frame rate                         frameRate(24);

                                        xstart = random(10);
                                        ystart = random(10);
                                        }

                                        void draw () {
Clears background every frame           background(0);

Increments x/y                          xstart += 0.01;
noise start values                      ystart += 0.01;

                                        xnoise = xstart;
                                        ynoise = ystart;

                                        for (int y = 0; y <= height; y+=5) {
                                          ynoise += 0.1;
                                          xnoise = xstart;
                                          for (int x = 0; x <= width; x+=5) {
                                            xnoise += 0.1;
                                            drawPoint(x, y, noise(xnoise, ynoise));
                                          }
                                        }
                                        }

                                        void drawPoint(float x, float y, float noiseFactor) {
                                        pushMatrix();
                                        translate(x,y);
                                        rotate(noiseFactor * radians(540));
                                        noStroke();
                                        float edgeSize = noiseFactor * 35;
                                        float grey = 150 + (noiseFactor * 120);
                                        float alph = 150 + (noiseFactor * 120);
                                        fill(grey, alph);
                                        ellipse(0,0, edgeSize, edgeSize/2);
                                        popMatrix();
                                        }
```

The **drawPoint** function is unchanged, as are the x within y loops to traverse the grid. What's new is that with every frame, you increment the start point for both the x and y noise seeds. When you run this, you'll see something very similar to figure 5.4; but now clouds are drifting diagonally across the screen, as if a steady wind were blowing from the southwest. There are no moving parts—the illusion is created by scrolling across the noise plane.

Obviously, it's a little difficult for me to demonstrate this in print, so you'll need to be coding along to appreciate the effect. This movement seems a little predictable for my liking, though. If only there were some way to produce a smooth, natural variance. Take a look at the next listing.

Listing 5.4 Noise grid with noise variance added to the movement

```
float xstart, xnoise, ystart, ynoise;
float xstartNoise, ystartNoise;

void setup() {
  size(300,300);
  smooth();
  background(255);
  frameRate(24);

  xstartNoise = random(20);          Uses noise for
  ystartNoise = random(20);          start positions
  xstart = random(10);
  ystart = random(10);
}

void draw () {
  background(255);

  xstartNoise += 0.01;
  ystartNoise += 0.01;               Varies by +/- 0.25
  xstart += (noise(xstartNoise) * 0.5) – 0.25;   every frame
  ystart += (noise(ystartNoise) * 0.5) – 0.25;

  xnoise = xstart;
  ynoise = ystart;

  for (int y = 0; y <= height; y+=5) {
    ynoise += 0.1;
    xnoise = xstart;
```

(continued on next page)

```
  for (int x = 0; x <= width; x+=5) {                              (Listing 5.4 continued)
    xnoise += 0.1;
      drawPoint(x, y, noise(xnoise, ynoise));
    }
  }
}

void drawPoint(float x, float y, float noiseFactor) {
  pushMatrix();
  translate(x,y);
  rotate(noiseFactor * radians(360));
  stroke(0, 150);
  line(0,0,20,0);
  popMatrix();
}
```

The extra code before the grid loop uses two (one-dimensional) noise sequences to give a drifting camera position, floating over the noise plane with the gentle irregularity of a leaf in an updraft. You'll notice for this example I rolled back the **drawPoint** function to the rotating-lines version from the previous section. Adding time to this particular visualization produces a nice illusion of ruffling fur, or the wind blowing through grass. Run it to see it in action.

Note that there is no limit to the number of noise sequences you can have in a single script. Listing 5.4 has four: **xnoise** and **ynoise**, which are combined to get a two-dimensional value; and **xstartNoise** and **ystartNoise**, which each give one-dimensional directional movement.

Next, we'll explore new depths, as you learn how Processing draws in 3D.

5.3 The third dimension

When you use the **size** function to specify the canvas area, there is a third, optional, parameter—**MODE**—that you haven't needed to know about until now. This is how you tell Processing which rendering engine to use:

```
size(width, height, MODE);
```

Table 5.1 Processing's choice of renderers

MODE VALUE	DESCRIPTION
JAVA2D	The default. The highest-quality 2D renderer.
P2D (Processing 2D)	A faster 2D renderer, optimized for pixel data, but not usually as accurate as JAVA2D.
P3D (Processing 3D)	A fast 3D renderer, intended for Java on the web. Prioritizes speed and file size over quality.
OPENGL	A better high-speed 3D renderer that utilizes OpenGL graphics hardware, if available. OPENGL smoothes all graphics, so smooth and noSmooth commands become redundant. You need to import the OpenGL library to use this renderer (see listing 5.5).
PDF	A renderer for writing directly to PDF files, rather than the screen. This is ideal for drawing high-resolution vector shapes, particularly when you're creating prints bigger than the screen (when you'd need to save to a file to see the results anyway). Requires the PDF library. For more information, see http://processing.org/reference/libraries/pdf/.

The list of renderers is in table 5.1. The default is JAVA2D, which produces the best two-dimensional images; this is what you've used up until this point. To draw in 3D, you'll need to change **MODE** to either P3D or OPENGL. OPENGL usually gives better-looking results, but only P3D produces an applet small enough to publish to the web. For the purposes of this chapter, it doesn't matter much which you choose.

Now, if you've chosen a renderer, let's try drawing something.

5.3.1 Drawing in 3D space

You're by now quite familiar with two-dimensional Cartesian coordinates, which is how you measure x and y positions on the canvas. To draw in 3D, you need to add an extra position—a z value—to measure how far you are above or below the 2D plane.

As with 2D drawing, Processing has a number of built-in functions for common 3D structures. You can begin using these to get a sense of drawing in a three-dimensional space. For this first example, you'll use **sphere**. You'll do the drawing using **translate** to move to a 3D position and then drawing relative to that point. You'll find this is the only sensible option when dealing with x, y, and z coordinates.

Open a fresh window, and type the following:

```
import processing.opengl.*;

size(500, 300, OPENGL);
sphereDetail(40);

translate(width/2, height/2, 0);
sphere(100);
```

The first statement imports the OpenGL library. This line is added automatically if you import the library via the Sketch menu (Sketch > Import Library). The **size** command then sets the canvas size and selects this renderer.

Next, the **sphereDetail** command tells the renderer how much detail to use when drawing a sphere. 3D renderers can't draw smooth curves, so any shape will always be made up of a collection of flat planes. By giving this command a value of 40, you effectively tell the renderer to make a new edge every 9 (360/40) degrees.

The final two lines create the sphere by moving the drawing point to the middle of the canvas and drawing a sphere around that point with a radius of 100. Notice how you pass three variables to the **translate** command, but you aren't using z yet. The output is shown in figure 5.5.

Figure 5.5

A sphere drawn using OpenGL

So far, barring the lines, this doesn't look too different from a circle created using the 2D renderer. But if you start modifying the third parameter of **translate**, you'll see the difference. Change that line to **translate(250, 150, 50)**; the sphere now appears bigger. You've moved it 50 pixels closer to you (a value of -50 moves it further away). If you set the third parameter to 150 it will appear as if you're actually inside the sphere.

Let's now use this new perspective to look at the 2D noise plane from the last section from a fresh angle.

5.3.2 Three-dimensional noise

Begin by entering the code from the following listing into a new window.

Listing 5.5 2D noise from a 3D perspective

```
import processing.opengl.*;

float xstart, xnoise, ystart, ynoise;

void setup() {
  size(500, 300, OPENGL);
  background(0);
  sphereDetail(8);
  noStroke();

  xstart = random(10);
  ystart = random(10);
}

void draw () {
  background(0);

  xstart += 0.01;
  ystart += 0.01;

  xnoise = xstart;
  ynoise = ystart;

  for (int y = 0; y <= height; y+=5) {
    ynoise += 0.1;
```

(continued on next page)

(Listing 5.5 continued)

```
   xnoise = xstart;
   for (int x = 0; x <= width; x+=5) {
     xnoise += 0.1;
     drawPoint(x, y, noise(xnoise, ynoise));
   }
 }
}

void drawPoint(float x, float y, float noiseFactor) {
  pushMatrix();
  translate(x, 250 - y, -y);
  float sphereSize = noiseFactor * 35;
  float grey = 150 + (noiseFactor * 120);
  float alph = 150 + (noiseFactor * 120);
  fill(grey, alph);
  sphere(sphereSize);
  popMatrix();
}
```

Aside from the change in renderer, this is similar to listing 5.4. The main difference is to the **drawPoint** function. Instead of translating to a 2D point, you translate to a 3D point. The code reuses the y value for the z depth as a shortcut; doing so creates a tiered square, sloping

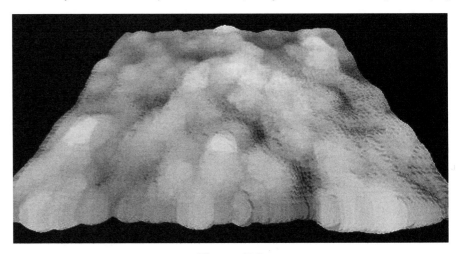

Figure 5.6

Two-dimensional noise, three-dimensional perspective

backward like theatre seating. At each 3D point, you create a sphere with a radius, fill color and alpha relative to the noise value. The result is another gently moving cloudscape, but with a better perspective (see figure 5.6).

The perspective is three-dimensional, while the plane you're looking at, and the noise sequence that defines it, remain essentially two-dimensional. But the **noise** function can take up to three parameters, so you have the capability to generate noise in three dimensions. The visual metaphor for three-dimensional noise will no longer be a mountain range: now you need to imagine a cloud, or a smoke-filled room, and consider how you might use that type of variance to create visualization. You can begin by building a controlled block of this noise.

You'll need to make a few changes to the loop. You'll now be iterating through all the points in a cube rather than a plane, and so you'll pass four parameters to the **drawPoint** function: x, y, z and the three-dimensional noise value for that point. The changes are made in the next listing.

Listing 5.6 Constructing a cube of three-dimensional noise

```
float xstart, ystart, zstart;
float xnoise, ynoise, znoise;

int sideLength = 200;
int spacing = 5;

void setup() {
  size(500, 300, P3D);                    Changes renderer to P3D
  background(0);
  noStroke();

  xstart = random(10);
  ystart = random(10);
  zstart = random(10);
}

void draw () {
  background(0);

  xstart += 0.01;
  ystart += 0.01;
  zstart += 0.01;
```

(continued on next page)

(Listing 5.6 continued)

```
xnoise = xstart;
ynoise = ystart;
znoise = zstart;

translate(150, 20, -150);
rotateZ(frameCount * 0.1);
rotateY(frameCount * 0.1);

for (int z = 0; z <= sideLength; z+=spacing) {
  znoise += 0.1;
  ynoise = ystart;
  for (int y = 0; y <= sideLength; y+=spacing) {
    ynoise += 0.1;
    xnoise = xstart;
    for (int x = 0; x <= sideLength; x+=spacing) {
      xnoise += 0.1;
      drawPoint(x, y, z, noise(xnoise, ynoise, znoise));
    }
  }
}
}

void drawPoint(float x, float y, float z, float noiseFactor) {
pushMatrix();
translate(x, y, z);
float grey = noiseFactor * 255;
fill(grey, 10);
box(spacing, spacing, spacing);
popMatrix();
}
```

Reposition to get a better perspective

Three loops now

The cube you build is made up of almost-transparent boxes, the color of which varies by the three-dimensional noise factor. It's still difficult to see, which is why you need the code to spin it around. You've essentially created a cloud in a box (see figures 5.7 and 5.8).

Calculating your way around three dimensions isn't straightforward: the math of 3D space is considerably more complicated than traversing a 2D canvas. But it comes with practice. After you've played with it a while and got the hang of it, you may consider taking the "break it down, build it back up" approach of the previous two chapters and trying it with 3D shapes. By way of example, we'll end this chapter with a quick look at the trigonometry of a sphere.

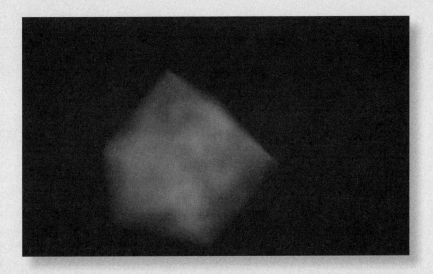

Figure 5.7

Three-dimensional noise: a cloud in a box

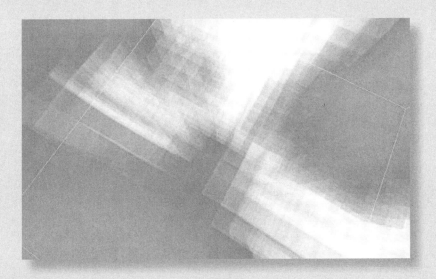

Figure 5.8

The source code for *Haunted Fishtank* (Abandoned Artwork #49), available at http://abandonedart.
org/?p=449, is similar to the system you've developed in this section.

5.3.3 The wrong way to draw a sphere

Below are the not-so-magic formulae for plotting points on the outer edge of a sphere. They're similar to the formulae for points on a circle (see chapter 4), but they require two angles (S and t) to determine a location relative to the center point:

```
x = centreX + (radius * cos(s) * sin(t));
y = centreY + (radius * sin(s) * sin(t));
z = centreZ + (radius * cos(t));
```

To construct a sphere without using Processing's **sphere** function, you'll take the same approach you did in section 4.1: iterate around rotations of these two angles. In doing so, you can project a line to every point on a sphere's outer surface.

See the following listing for one application of this technique. The *t* angle circles around the central axis many times in 18-degree jumps, while the *s* angle does one slow 180-degree rotation turn.

Listing 5.7 Spiraling around a sphere

```
import processing.opengl.*;

int radius = 100;

void setup() {
  size(500, 300, OPENGL);
  background(255);
  stroke(0);
}

void draw() {
  background(255);

  translate(width/2, height/2, 0);
  rotateY(frameCount * 0.03);
  rotateX(frameCount * 0.04);

  float s = 0;
  float t = 0;
  float lastx = 0;
  float lasty = 0;
  float lastz = 0;
```

```
while (t < 180) {
  s += 18;
  t += 1;
  float radianS = radians(s);
  float radianT = radians(t);

  float thisx = 0 + (radius * cos(radianS) * sin(radianT));
  float thisy = 0 + (radius * sin(radianS) * sin(radianT));
  float thisz = 0 + (radius * cos(radianT));

  if (lastx != 0) {
    line(thisx, thisy, thisz, lastx, lasty, lastz);
  }
  lastx = thisx;
  lasty = thisy;
  lastz = thisz;
  }
}
```

Converts angles to radians for trig

The result is a spiral drawn onto the surface of a virtual sphere, as shown in figure 5.9.

Figure 5.9
Spiraling around a sphere

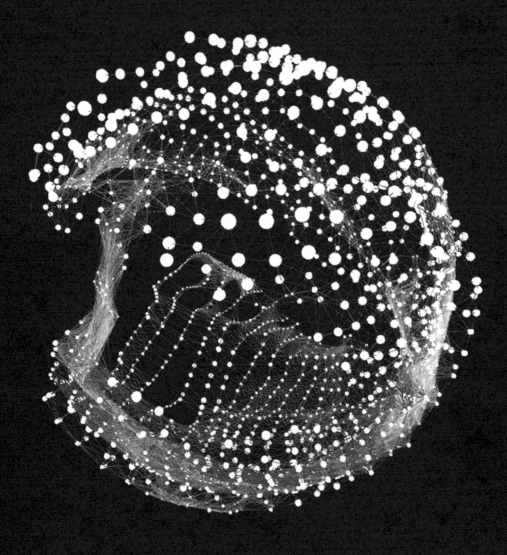

Figure 5.10

Frosti (2010). A video work created by applying Perlin noise to a deconstructed sphere:
http://vimeo.com/9712740

The three lines of trig at the beginning of this section have served me well in my own work. They're the core math wizardry behind my video piece *Frosti* (2010), for example (see figure 5.10). I leave you with this magic to make your own, to take and pervert into your own creations.

5.4 Summary

When an experiment feels like it has no further to go, you can always try adding an extra dimension. Be it a dimension in space or time. In this chapter, we've tried both. We've also introduced three-dimensional drawing in Processing, which can now be considered an extra string to your bow.

We have now, in this and previous chapters, pretty much exhausted Perlin Noise. Hopefully you now have a good appreciation of the range of effects you can produce with it. Anywhere we need a nice naturalistic variance it can be employed, which makes it such a useful convenience it is never going to fall too far down the toy box. I imagine it would be possible to spend a lifetime coming up with new ways to visualize this single algorithm, and when you tired of it you can change algorithm and waste a second lifetime.

As far as this book is concerned, we're putting down the **noise** and **random** functions for a while so we can look at a more organic way of exploring unpredictability. In part 3, we'll introduce an even cooler mathematical toy: *emergence*. We'll look at the simulation of natural processes, and practical ways of evoking natural forms the way they're constructed in the world outside of our laptops.

Part

three

Complexity

"The distinction that's new, and that we didn't used to make, is that something can be deterministic but not predictable. We tend to think they are synonyms but they're not.

Something can be obeying some law of nature but it's not predictable because what it's doing is so complicated that the time it would take you to calculate what it was going to do would take longer than the thing actually doing it.

So you could compute it but you can't compute the world any faster than it is happening. "

Rudy Rucker, in interview, 2007

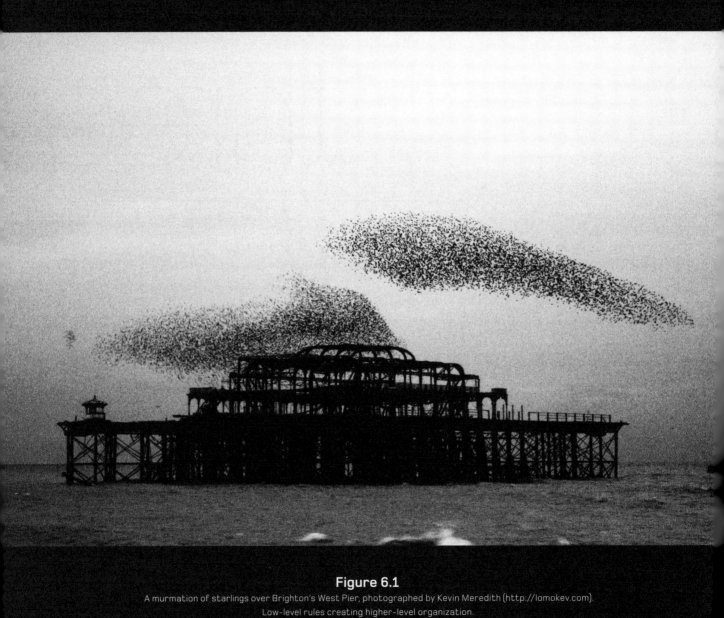

Figure 6.1
A murmation of starlings over Brighton's West Pier, photographed by Kevin Meredith (http://lomokev.com).
Low-level rules creating higher-level organization.

Emergence

I live in Brighton, on the southern coast of England. I moved here after a lifetime of living in urban environments; so I was, and remain, enraptured by the view to the south, where there is nothing but sea and sky. I used to walk home past Brighton's West Pier, a once-beautiful Victorian pleasure palace, abandoned since the 1970s and burned to a skeleton in 2003. It's now home to many thousands of starlings, and every night shortly before the sun goes down they perform a stunning murmation, circling in complex formations before settling to roost (see figure 6.1).

I find these formations mesmerizing, because they appeal to both sides of my brain. One hemisphere appreciates the natural aesthetic beauty of these creatures in motion and the shapes they form, but there is also the mathematical beauty of the flocking algorithm they are following, that challenges my logical side. Each bird in the formation is obeying simple instincts, oblivious to the higher-level pattern the flock is creating. Their behavior is defined by a small set of rules—orienting themselves in relation to their immediate neighbors, seeking the center of the flock, avoiding the paths of other birds—but these simple low-level rules, when applied en masse, create patterns of abstract beauty on a higher level.

6.1 Emergence defined

This phenomenon, whereby a simple rule set at a low level creates organized complexity on a higher level, is called *emergence*. The term was first coined in the mid-19th Century by George Henry Lewes, the English psychologist, philosopher, and sometime lover of George Eliot, in a paper on the mind; but notions of the whole being greater than the sum of its parts can be dated back as far as Aristotle. In recent decades, the concept of emergence has found a new relevance and wider popularity through its application to Complexity theory, first by John Holland in his book *Emergence* (1989), and later for a more popular audience by Steven Johnson in a 2001 book of the same name.

In a nutshell, *emergence* is the observation of how complex and coherent patterns can arise from a large number of small, very simple interactions. The classic example is the ant colony, an organism that has clearly defined, logical and coherent behaviors observable on two different scales. When we study the patterns of each ant, we see that each one has needs, abilities, and pheromone responses that define its behavior as an individual insect. But when we study the collective behavior of the colony, we again see sophisticated behavioral patterns; the colony operating like a city, with factories, defenses, and waste-disposal facilities. What is remarkable is the fact that these macro patterns aren't formed through any central design or intent: they're nothing more than *byproducts* of the local self-interested behaviors of the individuals collectively. These behaviors, seemingly insignificant on the micro level, form a more complex macro-organism when viewed collectively.

This is the principle we'll be trying to harness in the next few chapters. When you create a large number of small agents with simple behaviors, collectively they can become capable of producing a more complex, emergent, behavior on the macro level.

6.1.1 Ant colonies and flocking algorithms

The common myth, still prevalent today among lazier minds (including the makers of animated films) is that ant colonies operate in a hierarchical organization, with the queen at the top of a chain of command. With our human-centric perspective, this is the type of organizational patterns we find ourselves seeking; but the myth has been debunked in studies as far back as the 1970s. No central organization defines the structure and operation of an ant colony. All these global-level patterns and structures arise as the result of a large number of local-level micro-decisions. Design, hierarchy, pacemakers, and any other form of higher-level influence have no part in it.

Figure 6.2

Blonde Boids (Abandoned Artwork #4) was my adaptation of Dan Shiffman's adaptation
of Craig Reynolds Boids code.

The role of the queen is as perfunctory as that of every other ant with a job to perform within the greater whole. There is no trickle-down command; the ants' organization is from the bottom up. It is grass-roots. Emergent.

Similarly, the murmating starlings aren't following a leader as they swirl around the West Pier. The flock is made up of individuals, with individual behavioral impulses. Each starling looks only to its immediate surroundings and the movement of its closest neighbors to define the speed and orientation of its flight. This effect has been modeled in computing, most famously by Craig Reynolds in his *Boids* algorithm, first published in 1987. Reynolds discovered that to produce a realistic flocking simulation in code, he needed only three rules:

- *Separation*—Steer to avoid your immediate neighbors.

- *Alignment*—Steer to align with the average heading of your immediate neighbors.

- *Cohesion*—Steer toward the average position of your immediate neighbors.

More complex rules can be added (object avoidance, for example), but these three are all that are required to achieve a complexity comparable with the West Pier starlings. Dan Shiffman (and others) have created Boids implementations in Processing, which are fun to adapt. I won't reproduce the code here, because it's a little lengthy and more complex than required for the purposes of this chapter; but you can copy it from http://processing.org/learning/topics/flocking. html if you want to play with it. One example of my experiments with this code is shown in figure 6.2, and there are more sophisticated adaptations among the color images in the introduction.

It's difficult to get far with flocking algorithms, and other forms of emergent code, without a basic understanding of object-oriented approaches to programming. This is the main thrust of this chapter and something we'll get on to in section 6.2. But before we do, I want to give you a little more context on what emergence means from a sociological perspective.

6.1.2 Think locally, act locally

The concept of emergence, particularly in relation to both the natural world and society, has necessitated a steady political shift upon its path to wider, mainstream acceptance. The concept was extremely left-field in the 1950s (Alan Turing's final work before his death in 1954 was on the subject of morphogenesis: the way patterns formed in nature through emergent rules), groundbreaking in the 1970s and 80s, and the subject of excited discussion in the 1990s. It's only now becoming more comfortable and familiar in the web-savvy 21st century, because the internet has played no small part in changing the way we view other forms of organization.

The idea that a self-organized collective—be it the single cells of a slime mold, the ants of a colony, the human inhabitants of a city, or the globally distributed users of the web—can organize themselves into coherence is understandable and acceptable in a world where we conduct much of our intellectual discourse via the distributed nodes of the internet. Most of us can grasp how a network like Twitter, for example, can have a significant sociological meaning, even though each of its single 140-character tweets is near meaningless.[1] Each user's tweeting is either entirely self-interested or influenced by a small local group of a few hundred followers. But the meta-patterns of this chatter, when multiplied by hundreds of thousands, shape themselves into cultural shifts and global opinions. All we need is the right perspective, tools, or visualizations to be able to appreciate them.

Emergent networks like this have incredible but subtle strength and resilience. Their power is in their distribution. Each node is too small to be meaningful individually, so it's difficult to target, influence, or attack an emergent body. The internet avoids the vulnerabilities of a centralized organization in the same way a slime mold does: if a single node were to be lost or damaged, the greater whole would feel little effect. Distributed file-sharing networks share this principle, resilient to legislation because there is no central point to target.

1. The Twitter protocol itself may be seen as an emergent phenomenon. Its syntax (hashtags, @ addresses, and so on) were never designed by its creators but have been adopted from the bottom up, through their use by the collective.

Clearly, there are political connotations here. Emergence may suggest that, if it works so well for the natural world, central organization in the human world — governments, institutions — may be largely redundant. Ants follow local pheromone cues, oblivious to the effect of their decisions on the colony as a whole, just as humans give their local concerns (wealth, status, security, and so on) priority over the needs of the macro-organisms they form (groups, cities, countries). While our grander objectivity acknowledges that our car use is having devastating environmental effects on a global scale, it doesn't influence many to sacrifice the convenience a car allows them to get to the supermarket a little quicker. Even an understanding of the greater whole and how the effect works doesn't change the micro-behavior.

Many newer, more radical groups have acknowledged and embraced emergence as an organizing principle. Anti-globalization and environmental protest groups, for example, have explicitly modeled themselves after distributed, self-organized systems, as have the champions of file sharing.

There is a theory from the realms of neuroscience that argues that perhaps consciousness itself — the sense of self that is interpreting these words — is an example of emergence, being a macro-level coherence formed from the micro-interactions between firing synapses within our brains. Our whole sense of being may be an emergent effect.

It's a concept with many applications and theories across many disciplines; but for our interests, emergence is of relevance as a way of generating organic artworks. It's relevant first because emergence dictates how many forms of the natural world organize and construct themselves. If you wish to resonate with this aesthetic, you should pay attention to how it works. Second, within a methodology whereby you work with the simple logic of the programming language, where you encourage artworks to grow from logical seeds, and you wish to evolve a complexity sufficient to be visually interesting, the principles of emergence seem to be an ideal tool for getting complex results from simple code.

Until now, you've relied heavily on randomization and noise functions as ways of introducing unpredictability to your creations; but you'll discover that you don't always need such an obvious approach. You can program algorithms with a simplicity your animal brain can understand, but which through minimal abstraction can develop a complexity beyond what you could predict.

Over the coming pages we'll explore emergence in code. In the section to follow, you'll stumble across it as an accidental byproduct of simple programming. Then, in chapter 7, you'll create it again via the more organized approach of cellular automata, among other ideas. Chapter 8, on the subject of fractals, then builds on this way of programming, adding the further concept of self-similarity. Throughout the chapters in this final part of the book, you'll see copious examples of code that mirrors the organizational principles of the natural world.

6.2 Object-oriented programming

There is a mission to the rest of this chapter: we're going in search of the emergent complexity I just described. But in order to do this through the medium of code, we first need several new tools. In the next few pages, you'll learn the basics of object-oriented programming (OOP). If you're a seasoned programmer, you're probably already familiar with this concept—very few languages above a certain power and sophistication don't accommodate object-oriented structures. But even if you're on familiar ground, please bear with me, because OOP is only half of what I'm trying to illustrate.

If you've never heard the term before, OOP is just a small conceptual leap in how you think about coding. Rather than giving the machine the task of dealing with a linear progression of instructions, which is what you've done so far, you think in terms of creating *objects* in memory: self-contained data boxes that you can then use within the familiar linear programming style.

This conceptual shift is sometimes a little difficult for beginners, but it's nothing to be scared of. All it's really going to involve initially is drawing some circles and seeing where it takes you. Remember that what you're really doing in this chapter is seeking emergent complexity, and I guarantee it won't be long until you see some. First, let's look at classes and instances.

Figure 6.3
The output of listing 6.1: randomly generated circles

6.2.1 Classes and instances

Let's start simple. The following listing creates a script that draws a handful of randomly placed circles every time the mouse is clicked.

Listing 6.1 Code to draw a few circles at the click of the mouse

```
int _num = 10;

void setup() {
  size(500,300);
  background(255);
  smooth();
  strokeWeight(1);
  fill(150, 50);
  drawCircles();
}

void draw() {

}

void mouseReleased() {
  drawCircles();
}

void drawCircles() {
  for (int i=0; i< _num; i++) {
    float x = random(width);
    float y = random(height);
    float radius = random(100) + 10;
    noStroke();
    ellipse(x, y, radius*2, radius*2);
    stroke(0, 150);
    ellipse(x, y, 10, 10);
  }
}
```

I hope you can follow what's happening here. The script creates 10 circles at random positions on the screen every time you click the mouse. Try it a few times to get something similar to figure 6.3.

So far, the circles are pretty unsophisticated. They're thrown at the screen and left there, and you don't have any way to do anything further with them. If you reapproach the circles and define them in a more organized way, you'll find they're capable of a little more life. Instead of just telling Processing to draw a circle, let's instead create a circle *object*. The circle object will encapsulate everything there is to know about itself, which at the moment isn't much more than the x,y of its center point, and its radius.

An object, in programming, isn't too dissimilar from the concept of an object in the real world. Imagine a rock: this is an object. It has *properties*—color, weight, roughness—just as the circle object has an x,y and a radius. There are also things you can do with the rock: it has *functions*; it can be thrown, it can be hit with a hammer, it can be placed on a desk to use as a paperweight. It can also be disposed of before it becomes too convoluted a metaphor; let's do that and look instead at how you model an object in Processing.

Defining an object is very similar to defining a function. You use the **class** keyword to specify that this is a reusable object you're defining. Add the contents of the next listing to the bottom of your sketch.

Listing 6.2 A Circle class

```
class Circle {
  float x, y;
  float radius;
  color linecol, fillcol;
  float alph;

  Circle () {
    x = random(width);
    y = random(height);
    radius = random(100) + 10;
    linecol = color(random(255), random(255), random(255));
    fillcol = color(random(255), random(255), random(255));
    alph = random(255);
  }
}
```

Object properties — float x, y; float radius; color linecol, fillcol; float alph;

Object constructor — Circle () {

Object color and alpha — linecol = color(random(255), random(255), random(255)); fillcol = color(random(255), random(255), random(255)); alph = random(255);

What you have done here is not define a single object, but a class of all objects of that type. Think of it as a template that you can reuse. You don't need to make lots of different circles; you can just create an *instance* of the **circle** class, an object constructed according to the template you've defined.

Classes and instances

The difference between *classes* and *instances of those classes* is important. If you can digest this one concept, you've cracked OOP.

A *class* is a definition for a collection of objects. For example, if we define a class **80s English indie band**, it describes a number of objects with shared characteristics (guitars, backcombed hair, maudlin lyrics. and so on). We can make an instance of that class called **The Smiths** and a second instance called **Echo and The Bunnymen**. Both are independent of each other but can share common functionality; **recordAlbum()**, **featureInJohnHughesFilm()**, **splitAcrimoniously()**, etc.

The class is a template: it defines only the parameters these objects share, functions they can perform, and logic for how an object can be constructed. A class becomes an object only when you make an *instance* of it.

In one of our lazy human languages, you might say you once saw an **80s English indie band**, but what you mean is that you once saw one or more *instances* of **80s English indie band**. You can't get drunk and dance to a conceptual definition, no matter how post-modern you think you are.

Note that so far, this is purely conceptual. You haven't drawn a circle to the screen—you haven't even created a circle yet. You've just defined the template for it. To create an actual object from this template, an *instance* of the class, you call the constructor by using the **new** keyword, as demonstrated in this new version of the **drawCircles** function:

```
void drawCircles() {
  for (int i=0; i<_num; i++) {
    Circle thisCirc = new Circle();
  }
}
```

Fine so far, but you're still not actually drawing any circles, just creating them conceptually in memory. You've only defined the *properties* (variables) and the *constructor* (the function called when an object of that class is created) of the class so far. If you want to do something with the class, you need to add some *methods* (functions) to it, as per the following listing.

Listing 6.3 The Circle class again, with its first method

Properties

```
class Circle {

float x, y;
float radius;
color linecol, fillcol;
float alph;
```

Constructor

```
Circle () {
  x = random(width);
  y = random(height);
  radius = random(100) + 10;
  linecol = color(random(255), random(255), random(255));
  fillcol = color(random(255), random(255), random(255));
  alph = random(255);
}
```

Object method

```
void drawMe() {
  noStroke();
  fill(fillcol, alph);
  ellipse(x, y, radius*2, radius*2);
  stroke(linecol, 150);
  noFill();
  ellipse(x, y, 10, 10);
  }
}
```

Now, update the **drawCircles** function to call this method after you've created the object:

```
void drawCircles() {
  for (int i=0; i<_num; i++){
    Circle thisCirc = new Circle();
    thisCirc.drawMe();
  }
}
```

Et voilà, you have some circles, much as in figure 6.3. Great. This may seem like an awful lot of effort to get to where you were a few pages back. But when you start playing with the new structure, you'll see what you've gained by encapsulating the circles as objects. Now you can

give each of the circles actions, behaviors, and lives of their own. You could also give them feelings and opinions if you chose to, but we'll save that for chapter 7. For now, we'll concentrate on making them drift around and interact with each other.

Let's make another few updates to the code. In listing 6.4, you do the following:

- Create an array to store all the circles.
- Give each circle a movement factor in the x and y directions.
- Give each circle an **updateMe** method, called every frame by the **draw** loop.

Listing 6.4 **Object-oriented circle-drawing code with movement**

```
int _num = 10;
Circle[] _circleArr = {};                                          Define array of circles
void setup() {
  size(500,300);
  background(255);
  smooth();
  strokeWeight(1);
  fill(150, 50);
  drawCircles();
}

void draw() {
  background(255);
  for (int i=0; i<_circleArr.length; i++) {
    Circle thisCirc = _circleArr[i];
    thisCirc.updateMe();
  }
}

void mouseReleased() {
  drawCircles();
}

void drawCircles() {
  for (int i=0; i<_num; i++) {
    Circle thisCirc = new Circle();
    thisCirc.drawMe();
    _circleArr = (Circle[])append(_circleArr, thisCirc);          Add object to array
  }
```

(continued on next page)

(Listing 6.4 continued)

```
}

//===================================== objects

class Circle {

  float x, y;
  float radius;
  color linecol, fillcol;
  float alph;
  float xmove, ymove;

  Circle () {
    x = random(width);
    y = random(height);
    radius = random(100) + 10;
    linecol = color(random(255), random(255), random(255));
    fillcol = color(random(255), random(255), random(255));
    alph = random(255);
    xmove = random(10) – 5;
    ymove = random(10) – 5;
  }

  void drawMe() {
    noStroke();
    fill(fillcol, alph);
    ellipse(x, y, radius*2, radius*2);
    stroke(linecol, 150);
    noFill();
    ellipse(x, y, 10, 10);
  }

  void updateMe() {
    x += xmove;
    y += ymove;
    if (x > (width+radius)) { x = 0 – radius; }
    if (x < (0-radius)) { x = width+radius; }
    if (y > (height+radius)) { y = 0 – radius; }
    if (y < (0-radius)) { y = height+radius; }
```

Steps to move every frame

Random step

Move every frame

Wrap position
at stage edges

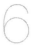
```
    drawMe();
  }
}
```

Now the circles are moving around. The **updateMe** method changes each object's x and y positions and wraps it if it's drifted offscreen. The **drawMe** method then renders the instance to the screen.

Using Arrays

An *array* is a list of objects of a certain type. If you define an array as
```
int[] numberArray = new int[5];
```

you're saying that you want a list of five items, all of type **int**.
You can specify what those five items are when you define the array using the braces syntax:
```
int[] numberArray = {1, 2, 3, 4, 5};
```

However you define it, you can add items to each position like so:
```
numberArray[2] = 3;
```

This places a 3 as the third item, not the second. The first position is index 0, so the third item is index 2.
An empty array, with no items, is defined as follows:
```
int[] numberArray = {};
```

To add an extra slot to an array and place data in that slot (as you do in listing 6.4), you use **append**. Note that you need to cast the new array returned by this command to the correct type, such as **int[]**:
```
numberArray = (int[])append(numberArray, 6);
```

Notice how, when you click to add more circles, the previous circles stay onscreen unchanged. You're still clearing the canvas every frame (you call **background(255)** in the **draw** frame loop); but because the objects remain in memory, they don't go anywhere, so you can redraw them whenever you need them. Even if you didn't render them to the screen every frame, they would still be there in memory, following their paths invisibly.

If you click several times, bringing the circle count into the hundreds, then thousands, you'll notice that the performance of the movie starts to suffer. Depending on the speed of your machine, you can probably comfortably manage a few hundred circles independently moving around the screen before you see any sign of the animation slowing down, but you should start to get an appreciation of the limits of your processor.

You have the object-oriented structure, and you have an application capable of generating many, many simple objects. Next, lets look at how you might tweak this system and tease out some emergent patterns.

6.2.2 Local knowledge (collision detection)

An instance created from the **Circle** class has what we might call *self-awareness*. It knows everything there is to know about itself, but nothing about the environment it's in or how it's being used by the script. If this was one of the murmating starlings, it would be flying blind, unable to see its flock-mates. You can change this though, and give the objects created from the class some rudimentary senses.

You have all the circle objects in an array; so by looping through this array, which is available globally (to all objects), each object can test itself against every other object (regardless of whether that object is onscreen or not). For this example, you'll test to see if the current circle is overlapping any other circle. This is called, in gaming parlance, *collision detection*.

Collision detection (and *collision correction* — making an object react realistically to a collision) is one of the dark arts of games programming. To have a realistic physics systems, objects need to be able to have an awareness of the environment around them and its inhabitants, and be able to react to their surroundings. As environments get more complex, and the number of inhabiting objects increases, this becomes quite a processor intensive action to perform every frame loop, especially if objects are of peculiar shapes.

There are entire books devoted to this topic, and for our needs we don't require a realistic physics simulation, so we'll keep the example simple. When you're dealing with circles, you just need a bit of trig to check the distance between two points; and Processing has a built-in **dist** function that does the calculation for you. If you check the distance between the centers of two circles and subtract their radii, if anything is left, you know the two circles aren't touching. This calculation requires a few extra lines in the **updateMe** function, as you can see in the following listing.

Listing 6.5 Circle **class's** updateMe **method with added collision detection**

```
void updateMe() {
  x += xmove;
  y += ymove;
  if (x > (width+radius)) { x = 0 - radius; }
  if (x < (0-radius)) { x = width+radius; }
  if (y > (height+radius)) { y = 0 - radius; }
  if (y < (0-radius)) { y = height+radius; }
```

```
   boolean touching = false;
   for (int i=0; i<_circleArr.length; i++) {
    Circle otherCirc = _circleArr[i];
    if (otherCirc != this) {
     float dis = dist(x, y, otherCirc.x, otherCirc.y);
     if ((dis - radius - otherCirc.radius) < 0) {
      touching = true;
      break;
     }
    }
   }
   if (touching) {
    if (alph > 0) { alph--; }
   } else {
    if (alph < 255) { alph += 2; }
   }

   drawMe()
 }
```

**Loops through
other circles**

Don't test current circle

**Calculates distance
between circles**

The loop you've added checks through every other circle in the array and tests how far away it is. If it's overlapping, the **touching** flag is set to **true**, and it breaks out of the loop. The **if** statement then applies an effect depending on whether the circles are intersecting. If circles are overlapping, they fade. They increase in opacity if they're in the clear. This should mean that smaller circles, which overlap other circles less as they move around, tend toward solidity, whereas larger circles become more transparent. Run the code to see it in action.

I'm sure you can come up with something more visually interesting to do with this behavior, but before I leave you to play around with it, let's try a little something. Where circles collide, let's draw another circle at the midpoint between them.

6.2.3 Interaction patterns

The only potentially tricky bit here is calculating the midpoint between two circles that could be anywhere on (or off) screen. You need to ensure that all bases are covered. If the x position of the current circle is greater than the x position of the intersecting circle, the midpoint x is

```
x + (otherCirc.x – x)/2
```

If it's less, the midpoint is

```
otherCirc.x + (x - otherCirc.x)/2
```

This is one way of doing it, but there is a neater way that will cover both possibilities with a single line of code. The average of the two x values will give us the midpoint between them, you can calculate this by adding them together and dividing by 2.

```
(x + otherCirc.x)/2
```

The same applies in the y direction. When you have the x and y position, you can mark it by drawing a circle at that point, with the radius of the circle dictated by the size of the overlap. The updated method is shown next.

Listing 6.6 Circle **class's** updateMe **method again, now with circles**

```
void updateMe() {
    x += xmove;
    y += ymove;
    if (x > (width+radius)) { x = 0 - radius; }
    if (x < (0-radius)) { x = width+radius; }
    if (y > (height+radius)) { y = 0 - radius; }
    if (y < (0-radius)) { y = height+radius; }

    for (int i=0; i<_circleArr.length; i++) {
        Circle otherCirc = _circleArr[i];
        if (otherCirc != this) {
            float dis = dist(x, y, otherCirc.x, otherCirc.y);
            float overlap = dis - radius - otherCirc.radius;       ← Calculates overlap
            if (overlap < 0) {                                     ← Negative overlap = touching
                float midx, midy;
                midx = (x + otherCirc.x)/2;                        ← Calculates midpoint
                midy = (y + otherCirc.y)/2;
                stroke(0, 100);
                noFill();
                overlap *= -1;             4
                ellipse(midx, midy, overlap, overlap); 5
            }
        }
    }

    drawMe();
}
```

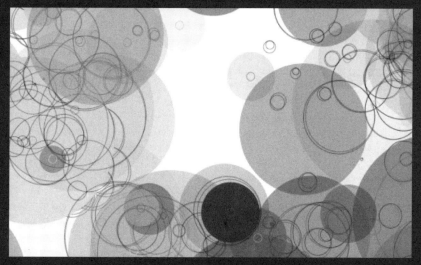

Figure 6.4
The circles are following a simple behavior you've programmed. But in the interaction between the circles, a new, emergent complexity is apparent.

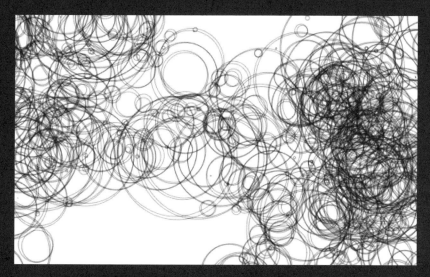

Figure 6.5
Removing the original behavior, all you have left are the emergent patterns, which are far more interesting.

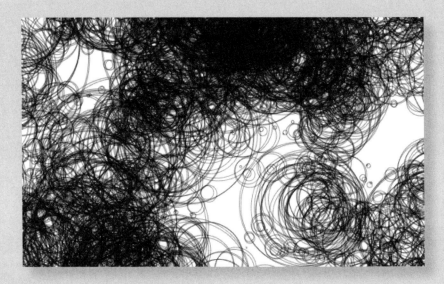

Figure 6.6

It took 170 circle objects to create this. I can only guess how many actual circles are on the screen.

Figure 6.7

The emergent circles, abstracted further using a softer line and traces

Run that, and you'll see a whole new pattern emerging. Figure 6.4 shows the output. You're drawing the circles, which position themselves according to the simple behavior you've given them, but you've also discovered an emergent property of the *interaction between* the circles. Abstracting this behavior by only a small degree, you've stumbled upon a new layer of complexity.

This new emergent behavior is clearly much more interesting than the simple one you built in the code. Let's isolate that so you can see it more clearly. If you comment out, or remove, the call to **drawMe** in the **updateMe** function, you get rid of the original circles. The circles are still there, of course; you're just not drawing them to the screen anymore. When you've done this, you have something that looks a little like figure 6.5.

Next, add a line to the mouse-press function to trace the current number of circles to the console window, so you can see how many circles you need to produce what effect:

```
void mouseReleased() {
  drawCircles();
  println(_circleArr.length);
}
```

I kinda liked 170 (see figure 6.6).

This clustering pattern, made up of nothing but circles, isn't a product of intention. The pattern is a byproduct of the *interactions* between the behaviors you programmed, not the behaviors themselves. Typically, it's in the interactions between agents that you find the emergent patterns. A single starling follows a flight pattern that obeys a set of rules; but place that bird in a flock, and the complexity of the pattern increases several-fold, while the rule set remains unchanged.

In this example, the behaviors couldn't have been much simpler: a number of objects moving in straight lines. And the drawing style was pretty basic, too. If you want to take this further, you can follow a lot of paths. To start you off, here are a few ideas. How about:

- *Leaving traces*—Don't clear the screen between frames. Draw a transparent rectangle over everything instead (as described in 2.4.2).

- *Reducing the alpha and stroke weight*—Make the lines more subtle to turn hard edges into an organic blur (see figure 6.7).

- *Plotting more complex paths*—You've already seen in previous chapters how there are far more interesting routes to take between two points than a straight line. How about plotting movement along a curve, for example?

- *Drawing more interesting shapes*—Draw something more exciting than a simple circle. You can even import images to be the visual representations of objects.

6.3 Summary

In this chapter, we've introduced the concept of emergence, discussed examples, and then, living up to my promise, discovered one of our own: an emergent effect from the simplest of objects behaving in the simplest of manners. I hope this has demonstrated how easy it is: how emergence isn't something you need to work at, it's something you may stumble upon almost by accident. Any system of many parts above a certain (relatively low) level of complexity, will be prone to emergent complexity. The only trick is exploiting it.

We haven't relied on randomness or noise to introduce the generative element to the code in this chapter. All we've done is apply a level of abstraction sufficient to introduce an unpredictable complexity. Simple rules creating complex results.

One other achievement we've unlocked in this chapter is the mastery of a very useful programming methodology: object-oriented programming. This will open us up to more advanced coding possibilities in the remaining chapters (and beyond).

In the next chapter, we'll stick with the topic of emergent complexity but take a more structured approach to its creation. We'll take our understanding of OOP and refine it toward a definition of agent-oriented programming.

Autonomy

Object-oriented programming (OOP) is a programming conceit. Objects are for organizing conceptual things into conceptual structures. An "object" can be anything: a speck within a particle system, a game character, a pure data form, or just a neat way of collecting variables and methods.

It doesn't necessarily have to correspond to anything that has a visual form or identity; it's a data holder. But you don't need to think of objects in such clinical terms. If you chose to define them so, you could give your objects feelings, aspirations, failings, and destinies. They can be active citizens in a virtual world, albeit a highly abstract one. Your objects can be more than data holders: they can be autonomous agents.

The difference between an object and an agent, in programming parlance, is that agents, specifically, observe and interact with their environment. They may have more sophisticated behaviors, such as goals, beliefs, and prejudices. They can also harbor imprecisions, self-interests, and irrationalities too, which is what makes them so interesting to work with.

This is what we mean when we speak of *autonomy*: the capability for something, whether human, monkey, software construct, robot, or supermodel, to make its own decisions. The difference between an agent and an object is the difference between an animal and a rock. You don't

necessarily have to anthropomorphize your objects to make them more interesting, but you might do so expecting the more complex, and less predictable, behavior you'd get from a creature rather than a data construct.

The most familiar single example of an autonomous agent, to you at least, is the one staring at this page. You, dear reader, with your behavior on any particular day defined by a complex mix of biology, psychology, and the comfortableness of your footwear, are an autonomous object, creating interesting patterns in the data you create. Most everything you do these days leaves a data trail: every purchase you make, every point you earn on your store card, every link you click, and every journey you take. The cards in your wallet are writing your economic autobiography, your tweets and SMSs are writing an ASCII diary as part of a social map, and the phone in your pocket is drawing a GPS picture of your daily psycho-geography.

In the second half of this chapter, we'll look at the concept of the agent further, discussing some particularly creative examples from both within and without our electronic boxes, including ways of tapping into the available mass of human-generated data for artistic use. But first, to familiarize you with the concept of autonomy and the emergent complexity of this breed of object, we'll play one of the early parlor games of computer science: cellular automata.

7.1 Cellular automata

We demonstrated in the previous chapter how easy it is to stumble across emergent complexity without particular intention. With the help of a cellular automata (CA) grid, you'll learn a more structured way of observing the phenomenon. In the 1970s, the field of computer science was obsessed with CA. Super-computers were employed to churn through iterations of John Conway's *Game of Life* (see section 7.1.2) over periods of weeks. Today, that kind of computing power is available in our mobile phones, so we can easily simulate cellular automata in a lightweight Processing sketch.

A 2D[1] CA is a grid of cells (see figure 7.1), each of which has only two states: on and off, black or white, alive or dead. Each cell has limited local knowledge, only able to see its eight immediate neighbors. In a series of cycles, each cell decides its next state based on the current states of its surrounding cells.

1. There are one-dimensional and multidimensional variants of CA, but for our purposes we'll stick to two dimensions.

Figure 7.1
A cellular automata grid

7.1.1 Setting up the framework

The best way to demonstrate is by example. The following listing creates a grid of cells with on/off states and a reference to their immediate neighbors.

Listing 7.1 CA framework

```
Cell[][] _cellArray;
int _cellSize = 10;
int _numX, _numY;

void setup() {
  size(500, 300);
  _numX = floor(width/_cellSize);
  _numY = floor(height/_cellSize);
  restart();
}

void restart() {
  _cellArray = new Cell[_numX][_numY];
  for (int x = 0; x< _numX; x++) {
    for (int y = 0; y< _numY; y++) {
      Cell newCell = new Cell(x, y);
      _cellArray[x][y] = newCell;
    }
  }
```

Creates grid of cells

```
  for (int x = 0; x < _numX; x++) {
    for (int y = 0; y < _numY; y++) {
```

Loop tells each object its neighbors

```
      int above = y-1;
      int below = y+1;
      int left = x-1;
      int right = x+1;
```

Gets locations to each side

```
      if (above < 0) { above = _numY-1; }
      if (below == _numY) { below = 0; }
      if (left < 0) { left = _numX-1; }
      if (right == _numX) { right = 0; }
```

Wraps locations at edges

```
   _cellArray[x][y].addNeighbour(_cellArray[left][above]);
   _cellArray[x][y].addNeighbour(_cellArray[left][y]);
   _cellArray[x][y].addNeighbour(_cellArray[left][below]);
   _cellArray[x][y].addNeighbour(_cellArray[x][below]);
   _cellArray[x][y].addNeighbour(_cellArray[right][below]);
   _cellArray[x][y].addNeighbour(_cellArray[right][y]);
   _cellArray[x][y].addNeighbour(_cellArray[right][above]);
   _cellArray[x][y].addNeighbour(_cellArray[x][above]);
  }
 }
}

void draw() {
 background(200);

 for (int x = 0; x < _numX; x++) {
  for (int y = 0; y < _numY; y++) {
   _cellArray[x][y].calcNextState();
  }
 }

 translate(_cellSize/2, _cellSize/2);

 for (int x = 0; x < _numX; x++) {
  for (int y = 0; y < _numY; y++) {
   _cellArray[x][y].drawMe();
  }
 }
}

void mousePressed() {
 restart();
}

//================================= object

class Cell {
 float x, y;
```

**Passes refs
to surrounding locs**

**Calculates next
state first**

Draws all cells

(continued on next page)

(Listing 7.1 continued)

On or off

```
boolean state;
boolean nextState;
Cell[] neighbors;

Cell(float ex, float why) {
  x = ex * _cellSize;
  y = why * _cellSize;
  if (random(2) > 1) {
    nextState = true;
  } else {
    nextState = false;
  }
  state = nextState;
  neighbors = new Cell[0];
}
```

Randomizes initial state

```
void addNeighbor(Cell cell) {
  neighbors = (Cell[])append(neighbors, cell);
}

void calcNextState() {
  // to come
}

void drawMe() {
  state = nextState;
  stroke(0);
  if (state == true) {
    fill(0);
  } else {
    fill(255);
  }
  ellipse(x, y, _cellSize, _cellSize);
}

}
```

It's a lengthy starting point, but nothing you haven't encountered before. At the bottom of the script you define an object, a **Cell**, which has x and y positions and a **state**, either on or off. It also has a holder for its next state, **nextState**, the state it will enter the next time its **drawMe** method is called.

In **setup**, you calculate the number of rows and columns based on the width and height and the size you want the cells; then, you call the **restart** function to fill a 2D array with this grid. After the grid is created, there is a second pass through the array to tell each of the cells who its neighbors are (above, below, left, and right of them).

The **draw** loop then does a double pass through the array. The first pass triggers each cell to calculate its next state, and the second pass triggers each to make the transition and draw itself. Note that this needs to be done in two stages so each cell has a static set of neighbors on which to base its next state calculation.

Now that you have the grid of cells (as shown in figure 7.1), you can begin giving the cells their simple behaviors. The best-known CA is John Conway's *Game of Life*, so that is the one we'll start with.

Multidimensional arrays

A one-dimensional array, as you saw in chapter 6, is a data structure for storing a list of elements. You define one as follows:

```
int[] numberArray = {1, 2, 3};
```

But if you want to store more than a list, if you have a matrix of elements to keep track of, you can add an extra dimension to the array. A 2D array is initialized like so:

```
int[][] twoDimArray = { {1, 2, 3}, {4, 5, 6}, {7, 8, 9} };
```

Essentially, you're defining an array of arrays. In listing 7.1, you can see an example of creating and iterating through a 2D array.

If you want more dimensions, you can have them. You're free to add as many dimensions as you can get your head around:

```
int[][][] threeDimArray;
int[][][][] fourDimArray;
...
```

Figure 7.2
Conway's Game of Life after 100 iterations

7.1.2 The Game of Life

The popularity of Conway's Game of Life (GOL) is mostly due to the relevance it has found outside the field of mathematics. Biologists, economists, sociologists, and neuroscientists, amongst others, have discussed at length the parallels between the behavior of CA obeying GOL rules and the results of studies in their respective fields. It's essentially a simple computational form of artificial life, a mathematical petri dish teeming with autonomous agents.

The rules for GOL are as follows:

- Rule 1: If a live (black) cell has two or three neighbors, it continues to live. Otherwise it dies, of either loneliness or overcrowding.

- Rule 2: If a dead cell has exactly three neighbors, a miracle occurs: it comes back to life.

You write this in code as follows. Complete the **calcNextState** function in accordance with the following listing.

Figure 7.3

Triangle height and rotation depend on the age of a cell. Triangle width is the neighbor count. The color of the shape is mixed using a combination of the two.

Figure 7.4

Circle size is determined by neighbor count. Lines and their rotations are determined by cell age.

Listing 7.2 Calculating the next state using GOL rules

```
void calcNextState() {
  int liveCount = 0;
  for (int i=0; i < neighbours.length; i++) {
    if (neighbors[i].state == true) {
      liveCount++;
    }
  }

  if (state == true) {
    if ((liveCount == 2) || (liveCount == 3)) {
      nextState = true;
    } else {
      nextState = false;
    }
  } else {
    if (liveCount == 3) {
      nextState = true;
    } else {
      nextState = false;
    }
  }
}
```

This code first counts the number of neighbors alive and then applies GOL rules. If you run it for a few seconds, you begin to see what looks like a microscope view of abstract organisms (see figure 7.2). Some parts bubble and then fade out; others achieve a looping stability. There has been much study of this game, identifying the mathematical "life" that forms: gliders, toads, boats, blinkers, beacons, and so on. The GOL Wikipedia page has many animated examples of the complex shapes and patterns that arise from these simple rules: see http://en.wikipedia.org/wiki/Conway's_Game_of_Life#Examples_of_patterns.

It would be very easy for us to get sidetracked here, because what you've written is essentially an AI program. Artificial intelligence is a field that, admittedly, has huge potential for the creation of generative art, but it's far beyond the scope of this book.[2] We'll keep our focus relatively shallow and toy with the possibilities for each of these cells, with its local, blinkered behavior, to render itself to the screen in visually interesting ways.

2. If this subject interests you, I suggest that you seek out Douglas Hofstadter's Pulitzer Prize winning *Gödel, Escher, Bach* (1979) as an entertaining, not too scary, starting point.

A simple black or white dot is only a starting point. Just as you did with multidimensional Perlin noise back in chapter 5, where you used the noise value as rotation, shape, size, and alpha values, you can try similar rendering experiments using a cell's properties. In the two examples in figures 7.3 and 7.4, I've used the number of live neighbors a cell has, and the number of frames it has remained alive, to determine the size, rotation, and color of a shape drawn at that cell's location. You may like to try similar experiments.

GOL is only one of many potential rule sets. In addition to experimenting with visualizations, I'd encourage you to try inventing your own. In the following pages, I'll demonstrate two more well-known patterns, and one invented behavior, each of which produces forms that have analogues in the natural world.

7.1.3 Vichniac Vote

The first pattern, the Vichniac Vote (after Gerard Vichniac who first experimented with it), is a lesson in conformity. Each cell is particularly susceptible to peer-group pressure and looks to its neighbors to observe the current trend. If the cell's color is in the majority, it remains unchanged. If it's in the minority, it changes. To ensure that there is an odd number of cells on which to make the decision, the cell includes its own current state in addition to its eight neighbors in making the calculation.

To see the vote in action, rewrite the **calcNextState** function using the code from the following listing. To create an artificial instability in the algorithm, you'll swap the rules for four and five neighbors; otherwise, it settles quickly into a static pattern.

Listing 7.3 The Vichniac Vote rule

```
void calcNextState() {
    int liveCount = 0;
    if (state) { liveCount++; }
    for (int i=0; i < neighbors.length; i++) {
        if (neighbors[i].state == true) {
            liveCount++;
        }
    }

    if (liveCount <= 4) {
        nextState = false;
    } else if (liveCount > 4) {
        nextState = true;
    }
```

Counts neighbors, including me

Am I in the majority?

(continued on next page)

(Listing 7.3 continued)

Swaps rules for 4 and 5

```
if ((liveCount == 4) || (liveCount == 5)) {
    nextState = !nextState;
}
}
```

The result is shown in figure 7.5. You can see how the clustering effect creates patterns similar to the hide of a cow, or the contours of a landscape seen from above.

With the Vichniac Vote, the rules you apply are sociological —agents succumbing to the peer-group pressure from their neighbors—but the results have an aesthetic more familiar from biology or geology. Might this imply that common computational principles underpin these disciplines? Before we've finished with this chapter and the next, you'll see plenty more algorithmic systems that may support this hypothesis. Brian's Brain, for example.

7.1.4 Brian's Brain

This is a three-state cellular automaton, meaning a cell can be in one more condition, apart from on or off. The states of a Brian's Brain CA are *firing*, *resting*, and *off*. It's designed to mimic the behavior of neurons in the brain, which fire and then rest before they can fire again. The rules are as follows:

- If the state is *firing*, the next state is *resting*.
- If the state is *resting*, the next state is *off*.
- If the state is *off*, and exactly two neighbors are firing, the state becomes *firing*.

You'll need to modify the cell class for this, as in the following code. Note that you have to change the type of **state** to **int**, so it can have more than two values. The integers 0, 1, and 2 indicate *off*, *firing*, and *resting*, respectively.

Listing 7.4 Cell object modified for the three-state Brian's Brain behavior

State 1, 2, or 0

```
class Cell {
    float x, y;
    int state;
    int nextState;
    Cell[] neighbors;

    Cell(float ex, float why) {
        x = ex * _cellSize;
```

(continued on next page)

Figure 7.5
The Vichniac Vote rule after 3 iterations, 11 iterations,
41 iterations, and 166 iterations

(Listing 7.4 continued)

```
y = why * _cellSize;
nextState = int(random(2));
state = nextState;
neighbors = new Cell[0];
}

void addNeighbor(Cell cell) {
  neighbors = (Cell[])append(neighbors, cell);
}

void calcNextState() {
  if (state == 0) {
    int firingCount = 0;
    for (int i=0; i < neighbors.length; i++) {
      if (neighbors[i].state == 1) {
        firingCount++;
      }
    }
    if (firingCount == 2) {
      nextState = 1;
    } else {
      nextState = state;
    }
  } else if (state == 1) {
    nextState = 2;
  } else if (state == 2) {
    nextState = 0;
  }
}

void drawMe() {
  state = nextState;
  stroke(0);
  if (state == 1) {
    fill(0);
  } else if (state == 2) {
    fill(150);
  } else {
    fill(255);
  }
  ellipse(x, y, _cellSize, _cellSize);
```

Counts firing
neighbors

If two neighbors
are firing, fire too

Else, don't change

If just fired, rest

If rested, turn off

Firing = black

Resting = grey

Off = white

```
    }

  }
```

The results look something like figure 7.6. Spaceships (the CA term, not mine) move across the plane in horizontal, vertical and sometimes diagonal directions.

Does this behavior reflect the way your thoughts form from the electronic bursts of firing synapses? Is what you're seeing a mathematical model of consciousness itself? Perhaps; but for our purposes, for the time being at least, it's just another emergent behavior that you can use as the basic for a generative visualization.

Just one more example before we move on. Not one of the famous rule sets, but a custom behavior instead. The patterns it produces should be quite familiar though.

Figure 7.6
The *Brian's Brain* behavior after 19 iterations

Figure 7.7
The customized wave rule after 6, 26, 49, and 69 iterations

7.1.5 Waves (averaging)

This final pattern is an example of a CA with a continuous behavior. There is no reason a cell has to be limited to two or three distinct values: its state can vary across a range of values. In this example, you'll use 255 values, the grayscale from white to black. This is a custom behavior, so it doesn't have a name, but I've based it on a standard physics model—averaging—whereby a chaotic state settles into a steady one thorough the influence of its neighbors.

The rules are as follows:

- If the average of the neighboring states is 255, the state becomes 0.
- If the average of the neighboring states is 0, the state becomes 255.
- Otherwise, new state = current state + neighborhood average – previous state value.
- If the new state goes over 255, make it 255. If the new state goes under 0, make it 0.

If you were adhering to the physics model, you'd need only the third of these rules. I've added the other rules for instability, to stop it from settling. The code is in the next listing. The output is shown in figure 7.7.

Listing 7.5 **Custom wave-like behavior**

```
class Cell {
  float x, y;
  float state;
  float nextState;
  float lastState = 0;
  Cell[] neighbors;

  Cell(float ex, float why) {
    x = ex * _cellSize;
    y = why * _cellSize;
    nextState = ((x/500) + (y/300)) * 14;          Creates initial gradient
    state = nextState;
    neighbors = new Cell[0];
  }

  void addNeighbor(Cell cell) {
    neighbors = (Cell[])append(neighbors, cell);
  }

  void calcNextState() {
```

(continued on next page)

(Listing 7.5 continued)

Calculate neighborhood average

```
float total = 0;
for (int i=0; i < neighbours.length; i++) {
  total += neighbors[i].state;
}
float average = int(total/8);

if (average == 255) {
 nextState = 0;
} else if (average == 0) {
 nextState = 255;
} else {
 nextState = state + average;
 if (lastState > 0) { nextState -= lastState; }
 if (nextState > 255) { nextState = 255; }
 else if (nextState < 0) { nextState = 0; }
}
```

Stores previous state

```
 lastState = state;
}

void drawMe() {
 state = nextState;
 stroke(0);
```

Uses state value as fill color

```
 fill(state);
 ellipse(x, y, _cellSize, _cellSize);
}

}
```

The most obvious comparison with this behavior is a liquid. Like rain on a shallow pool of water, it churns and varies.

The reason for this example is to emphasize how you can tweak not only the rules but also the framework itself. You don't need a grid, you don't need circles, and you don't need a limited set of grayscale values: your system can be as subtle and sophisticated as you care to make it (see figure 7.8). In the next section, we'll look at a few further simulation and visualization ideas that step far outside the ordered gird but still utilize agents, with their limited local knowledge, for emergent effects. We'll also look at the potential in exploiting one very familiar, oblivious data object: you.

Figure 7.8
Single-pixel-sized cells produce more subtle (but more processor-intensive) patterns.

7.2 Simulation and visualization

CAs may be of only limited interest to us visually. The real purpose of your experiments so far has been to drum in the agent-oriented approach, and the ways you can study the patterns that objects unwittingly create. CAs, for all their nerdy amusement value, may be only the simplest of possible systems you can visualize this way.

The coding part of this chapter is finished now, but there is plenty of scope to develop these approaches in more meaningful directions. For the remaining pages of this chapter, we'll discuss a few ideas.

7.2.1 Software agents

When you define a class in code, as you have a number of times now, you give it properties and methods: **x**, **y**, **height**, **width**, **alpha**; **update**, **draw**, **calcWidth**, and so on. But an object's properties and methods may just as easily be as follows:

```
class Agent {
  String political_leaning = "right";
  int num_years_in_education = 12;
  int salary = 30000;
  Agent[] neighbors;
  Agent[] coworkers;
  Agent[] friends;

  Agent() {
    num_years_in_education = 11 + int(random(8));
    if ((num_years_in_education < 13) {
      if (random(1) > 0.8)) {
        political_leaning = "right";
      } else {
        political_leaning = "left";
      }
    } else {
      if (random(1) > 0.3) {
        political_leaning = "right";
      } else {
```

```
        political_leaning = "left";
      }
    }
  }
}
```

If you give an agent real-world attributes, suddenly the simulations can take on more meaningful interpretations. The interactions of these simplified souls can say something about their less simple analogues: us. For example, you can query the thoughts or feelings of an agent, perhaps something like this:

```
boolean isHappy() {
if ((political_leaning == "right") {
  if (salary > 60000)) {
    return true;
  } else {
    return false;
  }
} else {
  if (friends.length > 25) {
    return true;
  } else {
    return false;
  }
 }
}
```

Given an infinite number of coders at an infinite number of MacBooks, you might follow this to its logical extreme and code an entire human being, and pack a bunch of them into a CA grid to see how they got on. Or, more interestingly, you could code up an artificial city environment to house them, and see the patterns they traced. But a human, or near-human, level of intelligence isn't needed for interesting agents, as you've already seen. It isn't the sophistication of the objects that produces the complexity; it's their large numbers and the way they interact with each other.

One of my favorite examples of an analogous agent-oriented system is Jeremy Thorp's *Colour Economy* (2008). He constructed a system whereby a number of colored cubes are given the ability to trade their own color value in the pursuit of profit (see figure 7.10). The set of rules each cube followed was the same, but each cube had different leanings and idiosyncrasies influencing its self-interested behavior; these collectively defined the unstable economics of the system.

Thorp visualized the cubes and their trades in both two- and three-dimensional views. There are some great videos of the system (built in Processing) in action on Jeremy's blog: http://blog.blprnt.com/blog/blprnt/the-colour-economy-the-gap-between-the-rich-and-the-poor.

The interplay between Thorp's cubes, although not smart enough to be considered true artificial intelligence, has sufficient complexity to model a system with obvious cultural parallels. His piece was more than a nice aesthetic: it was also a sociopolitical discussion point, commenting on consumerism, free trade, and the gap between rich and poor.

When you begin down a path of humanizing agents, inevitably you'll hit upon the obvious shortcut.

7.2.2 Human agents

The Apollo 17 Mission, the last (to date) of NASA's Moon landings, produced one of the most important photographs of the 20th century. The shot of Earth shown in figure 7.9, taken as the mission left Earth's orbit on its way out, was the first time the hairless apes, in their masses, had seen their planet like this. Before this photograph, we had highly detailed maps of the world and knew pretty much what it would look like when we got up there, but this was the first time we gained the perspective to see it for ourselves from so far away. It was a great leap in our anthropic subjectivity.

Figure 7.9
The "blue marble" photograph of Earth taken by Apollo 17, December 1972

Figure 7.10
Colour Economy by Jeremy Thorp (2008)

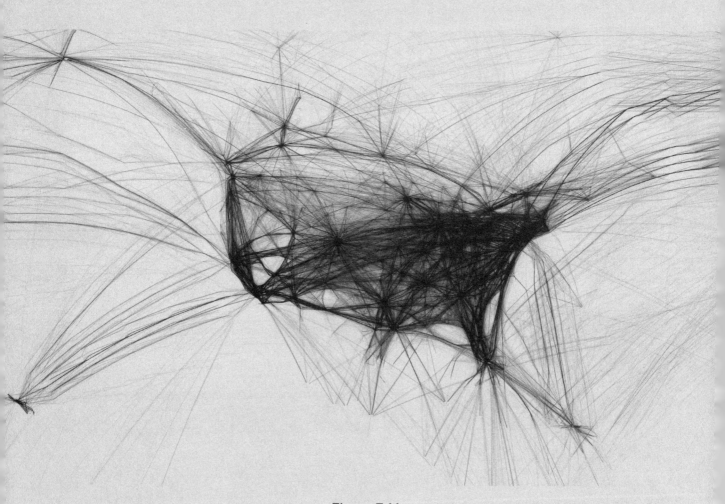

Figure 7.11
Aaron Koblin's *Flight Patterns* (2005): visualization of the flight paths of aircraft crossing North America

To the Google maps generation, this meta-view of the human race is becoming commonplace. It took only 40 years before the power of satellite imagery was on every laptop. It's one of those minor miracles we quickly take for granted when information technology accelerates at such speed. Couple this with a related technology, Global Positioning Systems (GPS), and you have the potential for a new form of unwitting artistic expression.

Your everyday movements leave a trail on the surface of the planet, and this trail draws a pattern. If you're a commuter, your GPS trail probably scores deep furrows as you repeat the same pattern day in day out; but on the weekend, your random psychogeography may create a more complex ballet. Viewed en masse, your data can produce much grander expression, as seen in Aaron Koblin's visualizations of the flight paths of aircraft crossing North America (see figure 7.11 and the color images in the introduction, figure i.18).

If you recall the opening chapters of this book, where I defined what generative art is (and isn't), one of the essential criteria was that the systems need to be autonomous: independent of outside control, free of any guiding hand. When you involve human beings with a generative system, their natural instinct is to attempt to influence it, which would remove the autonomy—*but only if the human's involvement in the system is conscious.* If the human agent is acting unaware, or uninterested, of the effect their actions are having on the system, they become as valid a data source as any other autonomous object.

Figure 7.12
Lunar Lander, the classic arcade game re-created in ActionScript

Figure 7.13
Lunar Lander Trails (2010), by Seb Lee-Delisle:
the actions of a many autonomous human agents

A fine example of this arose from a project created by my friend and colleague Seb Lee-Delisle (http://sebleedelisle.com). As an exercise in coding minimalism, he built an AS3 version of the old Lunar Lander arcade game (see figure 7.12), in less than 5 KB. Later, he used this as the basis for experiments with multiuser gaming, building a system to enable many users to play the game over the web. Seb threw his toy out there, inviting any of the great unwashed visiting his site to give it a play. But, unbeknownst to his users, he had the system record the paths they took as they maneuvered their landers safely to the lunar surface.

When he traced this data out onto a composite image, the result, through no intent or design, was surprisingly beautiful (see figure 7.13).

So, it would appear that there are only two challenges in using human agents in the creation of generative art: ensuring that they remain autonomous, and collecting the data. Once, the latter would have been a daunting task, but today it's simple. Data, particularly that relating to the hairless apes and their consumption habits, is being stockpiled as if it were the most valuable commodity we have—which some may argue it is.

Most web or mobile-device users leave these data trails routinely. There are patterns in Twitter streams, web browsing, and GPS location data that can be accessed via a variety of APIs available to programmers, usually for free. For example, more recent works by Jeremy Thorp have been based on the *New York Times'* API (http://blog.blprnt.com/blog/blprnt/7-days-of-source-day-6-nytimes-graphmaker), using Processing to visualize the occurrences of key phrases over the long periods covered by the newspaper's newly digitized archives. The agents in this system are journalists, doing their jobs and writing their articles, obliviously creating meta-patterns in the commonality of their language usage.

Data visualization is an artform in itself, one with huge potential. If you want to explore this area further, I'd suggest you try one of the following options as a launching point:

- Ben Fry's book *Visualizing Data* (O'Reilly 2007) covers the topic in depth, using Processing as the principle tool.

- For the coffee-break version, drop by Jeremy Thorp's blog, particularly the post http://blog.blprnt.com/blog/blprnt/your-random-numbers-getting-started-with-processing-and-data-visualization, which talks through getting Twitter data into a GoogleDocs spreadsheet, reading that spreadsheet into Processing, and visualizing the results.

- If you want to cut straight to the pretty pictures, you'll find plenty to feast your eyes on at www.informationisbeautiful.net and www.visualcomplexity.com

7.3 Summary

The object-oriented approach to code is just the start. With this approach, you can begin realizing more sophisticated systems. Your objects can be autonomous agents, interacting with each other in an artificial environment, producing emergent complexity for you to visualize, an idea you explored through cellular automaton experiments. You then went on to learn that agents don't have to fit such rigid constructs: they don't even need to be software-based. The potential in data visualization opens up a new field of art.

You may not be feeling like such a precious little flower after this excursion—after seeing yourself as the tiniest pixel of raw data, sand in God's great egg-timer. So, next we'll refocus, from the macro to the micro, into the intricacies of another natural construct: fractals. In the final chapter, we'll examine what they are, how to make them, and what you can do with them.

Figure 8.1

After experimenting with fractal structures, you'll start to notice self-similar recursion everywhere.
This illustration is from Ernst Haeckel's 1904 book *Kunstformen der Natur (Artforms of Nature)*

To my mind, there is something very "seventies" about fractal art. Even before James Gleick's hugely popular book *Chaos: Making a New Science* (1987), which popularized the mathematics of chaos theory, fractal imagery, in particular the Mandelbrot set, was overly familiar from the kind of posters you might expect to see on the walls of hippie math grads.

We'll never know why the renderers of early fractal art favored such lurid, psychedelic colors, but I assume it had a lot to do with the overconsumption of LSD. Anyway, I want this preconception of fractal art flushed from your mind as we explore self-similarity in this chapter. Fractal art can also be subtle and beautiful (see figures 8.1 and 8.2).

The code will be a little more involved in this, the book's final chapter, pushing the object-oriented organization we introduced in chapter 6 as far as your processors will allow. But this is about as difficult as generative art ever needs to get. If you can wrap your head around a self-similar recursive fractal structure and re-create it in code (a feat you'll be performing with great aplomb in a few pages' time), you'll find harnessing physics libraries, mechanical systems, fluid simulation, particles, AI, audio reactive art, or whatever explorations you want to pursue after you put this book down, won't present any barriers to you.

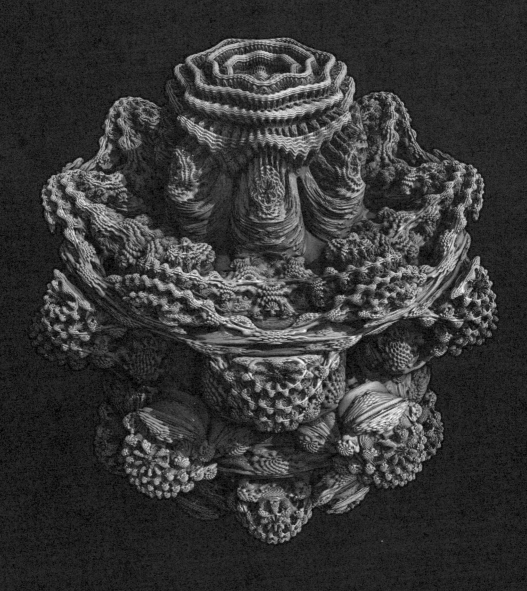

Figure 8.2

Mandelbulb by Tom Beddard (2009), www.subblue.com: a 3D version of the Mandelbrot fractal.
See Beddard's site or www.skytopia.com/project/fractal/mandelbulb.html for the math.

Fractals, from the Latin *fractus* (meaning "broken"), are shapes or patterns that repeat at many levels. The patterns don't necessarily need to be identical at the different scales; they just share certain types of *self-similar* structures. As with emergent patterns, fractal structures are everywhere in nature: in snowflakes, tree branches, rivers, coastlines, and blood vessels. The leaf of a fern is one particularly good example (see figure 8.3), where the fronds of each leaf mirror the shape of the leaf as a whole. Examine the frond in closer detail, and you'll see that its subdivisions are the same shape again. This self-similarity repeats, continuing downward in scale, beyond the limits of the human eye.

Figure 8.3

Ghost Ferns (photographed by Flickr user L'eau Bleue:)
fractal structures in nature

In this chapter, we'll look at fractal iteration as a way of creating art. You're already familiar with recursion: **for** loops, **while** loops, and **draw** loops. But this is a different breed of iteration, a reflexive iteration—a type that, unchecked, tends toward the infinite.

8.1 Infinite recursion

Imagine you're standing before a mirror, with a second mirror behind you. You see a reflection of a reflection of a reflection of a reflection, onward toward the limit of perception. Strange things happen when you have an infinite recursion like this. Small changes, micro-movements, become massively amplified within this closed loop. Try holding a flame in such a mirror loop (go on, put the book down and try it—it's really cool). The micro-randomness of the flame's flicker creates bizarre abstracts as it's repeated an infinite number of times. In the same way as the small interactions between many agents gave rise to an emergent complexity in the previous chapters, small changes in infinite, self-similar structures create a similar complexity, but on a more ineffable scale.

A computer can't deal with the concept of infinity. You can't ask a computer to loop an infinite number of times because, as a blind obeyer of instructions, it will never stop—the computer will loop for ever until you interrupt it or turn it off. This is Alan Turing's *halting problem:* he proved that in addition to it being impossible for an infinite loop to ever return a result, it's also impossible to determine in every case whether any given set of instructions will result in an infinite loop or reach a final state. This is one of the central concerns of the field of AI, that ultimate form of complexity we're gingerly skirting around in these chapters. Telling whether a problem is finitely soluble or not is something a human can do instinctively, but this ability can't be easily simulated by machines.

For example, you can tell at a glance that the following code will never reach a state where it stops:

```
int x = 1;
while (x>0) {
  x++;
}
```

This is an example of an infinite loop. It's perfectly syntactically correct, but it will lock the processor into a never-ending cycle until something interrupts it. Infinite loops are easy to code but are infinitely tedious to perform.

This is one thing to bear in mind as you begin coding reflexive iteration in the following section. Although fractals in the natural world have the potential to be infinitely recursive, you can only *simulate* infinite recursion in electronics. You don't have to worry about the halting problem, because, although Turing's famous proof rules out a *perfect* test for a non-halting state, modern syntax engines can usually warn against the *majority* of situations that may send the processor into a tailspin. And even if your engine doesn't warn you, all you have to do is quit Processing.

So, without further ado, let's code something and see what your machine can handle.

8.2 Coding self-similarity

The inevitable things in life are, as we know, death, taxes, and turning into our parents. This is why the concept of a child object that exactly resembles its parent object isn't going to be too foreign. This is how you'll create self-similarity: you'll define an object that acts as both child and parent and that creates a number of copies of itself. And of course, if one of the defining characteristics of an object is that it multiplies, you know that inevitably the objects will breed like rabbits.

We'll start with the structure and a familiar metaphor.

8.2.1 Trunks and branches

The first lines of code you'll write serve to set some limits. Without limits, you'll quickly fall into the trap of infinite recursion. Open a new sketch, and type

```
int _numLevels = 3;
int _numChildren = 3;
```

You're limiting the number of children each object can have and how many levels of recursive depth the system is allowed to go to. If you keep the numbers low to start with, you can maintain an appreciation for what is going on; then, you can kick the numbers up gently when you have something interesting. Bear in mind, though, that increasing the number of children by one isn't a process of addition, or even multiplication: it's raising to a power. Adding 3 levels, each with 3 children, is the equivalent of 3^3, which means 27 objects. Add 1 more child, and it becomes 3^4, which is 81 objects. Five levels with 5 children gives you 3,125 elements to control. This is why you need to tread carefully.

Call the class you're creating **Branch**, because a tree is a useful model. You can think of the first **Branch** as the trunk of the tree. Let's code it and see how far we can stretch this metaphor. The following listing is your starting point.

Listing 8.1 Coding a fractal structure, step 1

```
int _numChildren = 3;
int _maxLevels = 3;
    (continued on next page)
Branch _trunk;

void setup() {                                    (continued on next page)
```

(Listing 8.1 continued)

```
  size(750,500);
  background(255);
  noFill();
  smooth();
  newTree();
}

void newTree() {
  _trunk = new Branch(1, 0, width/2, 50);
  _trunk.drawMe();
}

class Branch {
  float level, index;
  float x, y;
  float endx, endy;

  Branch(float lev, float ind, float ex, float why) {
    level = lev;
    index = ind;
    updateMe(ex, why);
  }

  void updateMe(float ex, float why) {
    x = ex;
    y = why;
    endx = x + 150;
    endy = y + 15;
  }

  void drawMe() {
    line(x, y, endx, endy);
    ellipse(x, y, 5, 5);
  }
}
```

All the code does so far is

- Define and create an instance of a **Branch** object (the trunk).

- Call **drawMe** on that object.

The **Branch** object takes four parameters: **level**, **index**, **x**, and **y**. The level for the first branch, the trunk, is 1, and its index is 0 because there is only one of it. The **x** and **y** parameters are arbitrary points where you'd like to plant your tree. The object, when created, calls **updateMe**, which calculates an end point based on the start point you passed it. The **drawMe** function draws a line between those two points and a little circle to show its origin. Simple so far.

Next, let's get self-referential. Add a **children** array to the **Branch**'s properties, and update the **Branch**'s creation function to spawn new versions of itself. You pass each of the children the parent branch's end point as its start point, and the current level + 1. As long as you include the conditional **(level <= _maxLevels)**, you'll avoid infinite loops:

```
Branch [] children = new Branch[0];

Branch(float lev, float ind, float ex, float why) {
  level = lev;
  index = ind;
  updateMe(ex, why);

  if (level < _maxLevels) {
   children = new Branch[_numChildren];
   for (int x=0; x<_numChildren; x++) {
    children[x] = new Branch(level+1, x, endx, endy);
   }
  }
}
```

The result of this change means your single level-1 branch creates three level-2 children, each of which creates another three level-3 children. The total number of branches is therefore 1 + 3 + 9 = 13.

To see all the branches, you have to modify the **drawMe** function:

```
void drawMe() {
  line(x, y, endx, endy);
  ellipse(x, y, 5, 5);
  for (int i=0; i<children.length; i++) {
    children[i].drawMe();
  }
}
```

Notice how the app only needs to call **drawMe** on the trunk of the tree. The command trickles down to the children.

In order to be able to distinguish each branch, you'll need to vary their appearance a little. This is why it's useful for **Branch**es to know their own *level* and *index*. Change **updateMe** so it calculates the end point randomly, but weighted according to the level, as follows:

```
void updateMe(float ex, float why) {
  x = ex;
  y = why;
  endx = x + (level * (random(100) - 50));
  endy = y + 50 + (level * random(50));
}
```

And add a variation on the **strokeWeight** to the **drawMe** function:

```
strokeWeight(_maxLevels - level + 1);
```

If you run this, you have the beginnings of a fractal tree (see figure 8.4).

Next, you'll try animating it.

Figure 8.4

The beginnings of a fractal tree

8.2.2 Animating your tree

Okay, you have the structure, and you haven't broken your machine yet. Let's now add the **draw** loop, so you can animate this little guy:

```
void draw() {
  background(255);
  _trunk.updateMe(width/2, height/2);
  _trunk.drawMe();
}
```

Notice that you've moved the tether point to the middle of the stage (for neatness, you may want to change this in the **newTree** function too). Next, you need to add a few new properties to the **Branch** class to enable you to control drawing style, line length, and rotation (put them under the line **float endx, endy;**):

```
float strokeW, alph;
float len, lenChange;
float rot, rotChange;
```

You'll need to initialize these properties, giving each level its own **strokeWeight** and **alpha** and each branch its own randomized set of length and rotation properties. Add this code before the line **updateMe(ex, why);** in the **Branch** constructor function:

```
strokeW = (1/level) * 100;
alph = 255 / level;
len = (1/level) * random(200);
rot = random(360);
lenChange = random(10) - 5;
rotChange = random(10) - 5;
```

With these new properties, you can make the **updateMe** function actually *do* something when it's called every frame. You'll also give it the code to trickle down the command to its children so they can do something too, just as you did with the **drawMe** function. With this new version, the end point will be calculated according to the angle and length—plotting it as a point on the circumference of a circle of radius **len**. The angle to that point will change every frame, as will the length of the line. The new **updateMe** function is as follows.

Listing 8.2 updateMe **that calculates the end point according to a rotating angle**

```
void updateMe(float ex, float why) {
  x = ex;
  y = why;

  rot += rotChange;
  if (rot > 360) { rot = 0; }
  else if (rot < 0) { rot = 360; }

  len -= lenChange;
  if (len < 0) { lenChange *= -1; }
  else if (len > 200) { lenChange *= -1; }

  float radian = radians(rot);
  endx = x + (len * cos(radian));
  endy = y + (len * sin(radian));

  for (int i=0; i<children.length; i++) {
    children[i].updateMe(endx, endy);
  }
}
```

Increments rotation

Increments length

You can update the object's **drawMe** function to use the **strokeW** and **alph** properties you've defined and initialized. Also change the radius of the ellipse to be relative to the new variable length:

```
void drawMe() {
  strokeWeight(strokeW);
  stroke(0, alph);
  fill(255, alph);
  line(x, y, endx, endy);
  ellipse(endx, endy, len/12, len/12);
  for (int i=0; i<children.length; i++) {
    children[i].drawMe();
  }
}
```

The final code is in listing 8.4 at the end of the next section, if you want to skip ahead. The output at this stage should look something like figure 8.5, except that in your version it will be spinning crazily like space clockwork. We're purposely departing a little from the tree metaphor

Figure 8.5

Space clockwork: the beginnings of an animated fractal, spinning like a dervish

now. Every fractal programming tutorial I've ever read teaches you how to draw a tree and make it shake in the wind. But there are some things computers can do better than nature—one of which is space clockwork.

Next, it's time to turn it up to 11.

8.3 Exponential growth

Normally, the message at this point in the chapter would be to throw what you can at your structure and see what flies. But this time, let's tread a little more cautiously. If you just start adding zeros to **_numChildren** and **_maxLevels**, things will seize up. Instead, try pushing up the numbers more gently. The following pages show images from **_numChildren = 4; _maxLevels = 7;** (figure 8.6) and **_numChildren = 3; maxLevels = 10;** (figure 8.7). Already this was nearing the point when my machine was starting to grumble. My amorphous blob was still spinning, but with a little less pizzazz.

With a finer line (**strokeW = (1/level) * 10;**), you can get something that looks like figure 8.8. With this example I also added a conditional (**if (level > 1)**) to stop the **drawMe** function from drawing the trunk, which is clearly visible in figure 8.7.

Figure 8.6
Turning it up a little: four children, seven levels. I hope you're coding along so you can see this structure

Figure 8.7
3 children, 10 levels

Figure 8.8
A finer line, six levels, and seven children

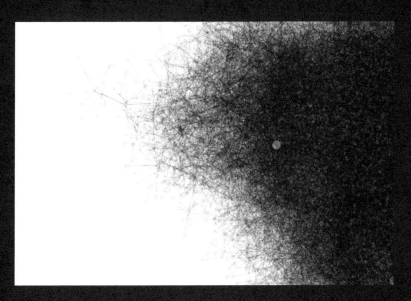

Figure 8.9
Seven children, seven levels: about as far as I could push it and expect it to animate

Figure 8.8 has six levels and seven children. Pushing that one further, to seven levels, yields something like figure 8.9. I found that was about the limit of what would still animate on my machine.

The complete code for this final version is in the following listing.

Listing 8.3 Final listing for the cog fractals

```
int _numChildren = 7;
int _maxLevels = 7;

Branch _trunk;

void setup() {
  size(750,500);
  background(255);
  noFill();
  smooth();
  newTree();
}

void newTree() {
  _trunk = new Branch(1, 0, width/2, height/2);
  _trunk.drawMe();
}

void draw() {
  background(255);
  _trunk.updateMe(width/2, height/2);
  _trunk.drawMe();
}

class Branch {
  float level, index;
  float x, y;
  float endx, endy;

  float strokeW, alph;
  float len, lenChange;
  float rot, rotChange;
```

```
    Branch[] children = new Branch[0];

    Branch(float lev, float ind, float ex, float why) {
    level = lev;
    index = ind;

    strokeW = (1/level) * 10;
    alph = 255 / level;
    len = (1/level) * random(500);
    rot = random(360);
    lenChange = random(10) - 5;
    rotChange = random(10) - 5;

    updateMe(ex, why);

    if (level < _maxLevels) {
     children = new Branch[_numChildren];
     for (int x=0; x<_numChildren; x++) {
      children[x] = new Branch(level+1, x, endx, endy);
     }
    }
    }

void updateMe(float ex, float why) {
    x = ex;
    y = why;

    rot += rotChange;
    if (rot > 360) { rot = 0; }
    else if (rot < 0) { rot = 360; }

    len -= lenChange;
    if (len < 0) { lenChange *= -1; }
    else if (len > 500) { lenChange *= -1; }

    float radian = radians(rot);
    endx = x + (len * cos(radian));
    endy = y + (len * sin(radian));
```

(Continued on next page)

```
                                                                              (Listing 8.3 continued)
    for (int i=0; i<children.length; i++) {
      children[i].updateMe(endx, endy);
    }
  }

  void drawMe() {

    if (level > 1) {

      strokeWeight(strokeW);
      stroke(0, alph);
      fill(255, alph);
      line(x, y, endx, endy);
      ellipse(endx, endy, len/12, len/12);
    }
    for (int i=0; i<children.length; i++) {
      children[i].drawMe();
    }
  }

}
```

Don't draw trunk

So far, we've looked at a single branching fractal structure, probably the simplest such system we might conceive. I'm not going to catalogue a long list of other possible shapes you could explore; I will leave the tinkering up to you. Instead, I'll finish the chapter, and the book, with one specific example: a shape that was shown to me by a wise old mathematician on a dark and slightly overcast night—a shape that I've had a lot of fun with since.

8.4 Case study: Sutcliffe Pentagons

In 2008 I went to a meeting of the Computer Arts Society (CAS) in London, an organization that was (remarkably, for a body devoted to computing) celebrating its fortieth anniversary with that event. There, I heard a short talk by the society's initiator and first chairman, the artist and mathematician Alan Sutcliffe.[1] Through this talk, he introduced me to a marvelous shape, which I have since mentally dubbed the *Sutcliffe Pentagon*.

1. Alan has written about the early days of the CAS in the book *White Heat Cold Logic: British Computer Art 1960–1980*, Paul Brown, Charlie Gere, Nicholas Lambert, and Catherine Mason, editors (MIT Press, 2008).

To be clear, I've spoken to Alan about this, and he isn't entirely over the moon with me using this name. He has been insistent that, even though he thought it up, he doesn't believe the shape was his invention. He cites Kenneth Stephenson's work on circle packing[2] as preceding him, in which Stephenson himself credits earlier work by Floyd, Cannon, and Parry.[3] But I have since reviewed

this trail of influence, and, although Sutcliffe's predecessors do describe a dissected pentagon, none of them take the idea half as far as he did. And even if they had, it wouldn't change the way the Sutcliffe Pentagon was burned into my brain that particular evening.

So, respecting Alan's modesty, and his proviso that we probably shouldn't, strictly speaking, refer to this construct as a Sutcliffe Pentagon, let me begin by showing you what a Sutcliffe Pentagon looks like (see figure 8.10). Then, I'll talk you though how to construct a Sutcliffe Pentagon, and finally I'll show you a number of different Sutcliffe Pentagon–derived works, developed using the Sutcliffe Pentagon structure.

Sutcliffe noticed that if you draw a pentagon, then plot the midpoints of each of its five sides and extend a line perpendicular to each of these points, you can connect the end of these lines to make another pentagon. In doing this, the remaining area of the shape also ends up being subdivided into further pentagons, meaning that within each pentagon are six sub-pentagons. And within each of those, another six sub-pentagons, repeated downward toward the infinitesimal.

If you don't find yourself overly thrilled by the mathematics of this yet, bear with me. In the following section, I'll show what you can do with this simple principle. Let's start by coding it up; then, I'll demonstrate some of the directions I took it in.

8.4.1 Construction

You begin by drawing a regular pentagon. But the way I approached it, you don't just draw five lines between five points; instead, you create a drawing method that is a little more generic— rotating 360 degrees around a center and extrapolating points at certain angles. For example, if you plot a point every 72 degrees, you get a pentagon.

2. Kenneth Stephenson, *Introduction to Circle Packing: The Theory of Discrete Analytic Functions* (Cambridge University Press, 2005).

3. J. W. Cannon, W. J. Floyd, and W. R. Parry, "Finite subdivision rules," Conformal Geometry and Dynamics, vol. 5 (2001).

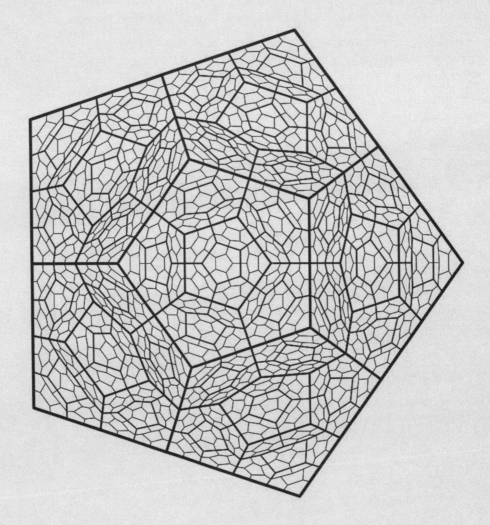

Figure 8.10

Sutcliffe Pentagons

Listing 8.4 Drawing a pentagon using rotation

```
FractalRoot pentagon;
int _maxlevels = 5;

void setup() {
 size(1000, 1000);
 smooth();
 pentagon = new FractalRoot();
 pentagon.drawShape();
}

class PointObj {
 float x, y;
 PointObj(float ex, float why) {
  x = ex; y = why;
 }
}

class FractalRoot {
 PointObj[] pointArr = new PointObj[5];
 Branch rootBranch;

 FractalRoot() {
   float centX = width/2;
   float centY = height/2;
   int count = 0;
   for (int i = 0; i<360; i+=72) {
    float x = centX + (400 * cos(radians(i)));
    float y = centY + (400 * sin(radians(i)));
    pointArr[count] = new PointObj(x, y);
    count++;
   }
   rootBranch = new Branch(0, 0, pointArr);
 }

 void drawShape() {
  rootBranch.drawMe();
 }
}
```

Creates root pentagon

Calls drawShape method on it

Object class to store an x, y position

(continued on next page)

(Listing 8.4 continued)

```
class Branch {
  int level, num;
  PointObj[] outerPoints = {};
```

Constructs Branch object

```
  Branch(int lev, int n, PointObj[] points) {
    level = lev;
    num = n;
    outerPoints = points;
  }

  void drawMe() {
    strokeWeight(5 - level);
    // draw outer shape
    for (int i = 0; i < outerPoints.length; i++) {
      int nexti = i+1;
      if (nexti == outerPoints.length) { nexti = 0; }
      line(outerPoints[i].x, outerPoints[i].y, outerPoints[nexti].x, outerPoints[nexti].y);
    }
  }
}
```

Branch draws itself

The **FractalRoot** object contains an array of five points. It fills that array by rotating an angle around a center point in 72-degree jumps. It then uses that array of points to construct the first **Branch** object. The **Branch** object is your self-replicating fractal object. Each branch draws itself by connecting the points it has placed in its **outerPoints** array.

This should give you a pentagon, as shown in figure 8.11.

Figure 8.11

Just in case you don't know what a regular pentagon looks like

Next, you plot the midpoints of each side. Add the two functions in the following listing to the **Branch** object.

Listing 8.5 Functions to calculate the midpoints of a set of vertices

```
PointObj[] calcMidPoints() {
  PointObj[] mpArray = new PointObj[outerPoints.length];
  for (int i = 0; i < outerPoints.length; i++) {
    int nexti = i+1;
    if (nexti == outerPoints.length) { nexti = 0; }
    PointObj thisMP = calcMidPoint(outerPoints[i], outerPoints[nexti]);
    mpArray[i] = thisMP;
  }
  return mpArray;
}

PointObj calcMidPoint(PointObj end1, PointObj end2) {
  float mx, my;
  if (end1.x > end2.x) {
    mx = end2.x + ((end1.x - end2.x)/2);
  } else {
    mx = end1.x + ((end2.x - end1.x)/2);
  }
  if (end1.y > end2.y) {
    my = end2.y + ((end1.y - end2.y)/2);
  } else {
    my = end1.y + ((end2.y - end1.y)/2);
  }
  return new PointObj(mx, my);
}
```

The first function, **calcMidPoints**, iterates through the array of outer points and passes each pair of points to the second function, **calcMidPoint**; this function works out the difference between each individual pair, covering every possible relative position to each other. **calcMidPoints** collects each of the results in an array to pass back.

You call the new function in the **Branch** constructor and put the result in an array named **midpoints**:

```
PointObj[] midPoints = {};

Branch(int lev, int n, PointObj[] points) {
  ...
  midPoints = calcMidPoints();
}
```

Then, you can plot those points in the **drawMe** function:

```
strokeWeight(0.5);
fill(255, 150);
for (int j = 0; j < midPoints.length; j++) {
  ellipse(midPoints[j].x, midPoints[j].y, 15, 15);
}
```

This gives you figure 8.12.

The next set of points you need are the ends of the struts to extend from the midpoints. You don't need to work this out relative to the angle of the side vertex; you can instead use one of the opposite points of the shape to aim toward.

First, define a global **_strutFactor** variable to specify the ratio of the total span you want the strut to extrude:

```
float _strutFactor = 0.2;
```

Now, the **Branch** object needs another set of functions to plot those points.

Figure 8.12

Calculating the midpoints of the sides

Listing 8.6 Functions to extend the midpoints toward the opposite points

```
PointObj[] calcStrutPoints() {
    PointObj[] strutArray = new PointObj[midPoints.length];
    for (int i = 0; i < midPoints.length; i++) {
      int nexti = i+3;
      if (nexti >= midPoints.length) { nexti -= midPoints.length; }
      PointObj thisSP = calcProjPoint(midPoints[i], outerPoints[nexti]);
      strutArray[i] = thisSP;
    }
    return strutArray;
}

PointObj calcProjPoint(PointObj mp, PointObj op) {
    float px, py;
    float adj, opp;
    if (op.x > mp.x) {
        opp = op.x - mp.x;
    } else {
        opp = mp.x - op.x;
    }
    if (op.y > mp.y) {
      adj = op.y - mp.y;
    } else {
      adj = mp.y - op.y;
    }
    if (op.x > mp.x) {
      px = mp.x + (opp * _strutFactor);
    } else {
      px = mp.x - (opp * _strutFactor);
    }
    if (op.y > mp.y) {
        py = mp.y + (adj * _strutFactor);
    } else {
        py = mp.y - (adj * _strutFactor);
    }
    return new PointObj(px, py);
}
```

Projects midpoint to opposite outer point

Trig calculations

Projects along hypotenuse

Figure 8.13
Project struts toward the opposite points

Again, add this code to the **Branch** constructor:

```
PointObj[] projPoints = {};

Branch(int lev, int n, PointObj[] points) {

  ...

  projPoints = calcStrutPoints();
}
```

And plot those points in the **drawMe** function so you can see they're correct:

```
strokeWeight(0.5);
fill(255, 150);
for (int j = 0; j < midPoints.length; j++) {
  ellipse(midPoints[j].x, midPoints[j].y, 15, 15);
  line(midPoints[j].x, midPoints[j].y, projPoints[j].x, projPoints[j].y);
  ellipse(projPoints[j].x, projPoints[j].y, 15, 15);
}
```

You should be looking at something like figure 8.13.

Figure 8.14

A recursive pentagon

Now you have all the points you need for the recursive structure. You can test this first by passing the five strut points as the outer points for an inner pentagon. Add the following to the **Branch** object's constructor:

```
Branch[] myBranches = {};

Branch(int lev, int n, Point[] points) {

  ...
  if ((level+1) < _maxlevels) {
    Branch childBranch = new Branch(level+1, 0, projPoints);
    myBranches = (Branch[])append(myBranches, childBranch);
  }
}
```

Then, add a similar trickle-down method to the **drawMe** function so the children are rendered to the screen:

```
void drawMe() {

  ...
  for (int k = 0; k < myBranches.length; k++) {
    myBranches[k].drawMe();
  }
}
```

You should see the result shown in figure 8.14.

Adding the other five pentagons to create a complete Sutcliffe Pentagon fractal is just a matter of passing the points to five more new **Branch** objects. The code is as follows:

```
if ((level+1) < _maxlevels) {
    ...
    for (int k = 0; k < outerPoints.length; k++) {
        int nextk = k-1;
        if (nextk < 0) { nextk += outerPoints.length; }
        PointObj[] newPoints = { projPoints[k], midPoints[k],
                outerPoints[k], midPoints[nextk], projPoints[nextk] };
        childBranch = new Branch(level+1, k+1, newPoints);
        myBranches = (Branch[])append(myBranches, childBranch);
    }
}
```

This gives you the fractal shown at the beginning of this section in figure 8.10. Now you can begin experimenting with it.

8.4.2 Exploration

You have the ratio of the projected strut in a handy variable, so let's start by varying this. You'll add a **draw** loop to redraw the fractal every frame with a new strut length, and vary that length by a noise factor. For this modification, you don't need to do anything to the objects—just update the initialization section of the code as shown in the following listing.

Listing 8.7 **Varying the strut length of a Sutcliffe Pentagon**

```
FractalRoot pentagon;
float _strutFactor = 0.2;
float _strutNoise;
int _maxlevels = 4;

void setup() {
    size(1000, 1000);
    smooth();
    _strutNoise = random(10);
}

void draw() {
```

Reduced to 4 to keep manageable

```
    background(255);

    _strutNoise += 0.01;
    _strutFactor = noise(_strutNoise) * 2;

    pentagon = new FractalRoot(frameCount);
    pentagon.drawShape();
}
```

Range of 0 to 2, not 0 to 1

**Re-creates fractal
every frame**

You make one other little change here: you pass the **frameCount** to the **FractalRoot** object. If you then modify **FractalRoot**, you can use that number to increment the angle and make the shape spin, Space Odyssey style:

```
FractalRoot(float startAngle) {
    ...
        float x = centX + (400 * cos(radians(startAngle + i)));
        float y = centY + (400 * sin(radians(startAngle + i)));
    ...
}
```

Also notice that the strut ratio doesn't just vary between 0 and 1, we've allowed it to go to 2, so it can extend beyond the limits of the shape. Does this work? Try it and see. How about if the strut ratio went into negative values? What would happen then? Only one way to find out:

```
    _strutFactor = (noise(_strutNoise) * 3) - 1;
```

In this case, the ratio varies between -1 and +2. You end up with an animation that produces shapes like those shown in figure 8.15.

Already it's getting interesting.

Although the pentagon has a neat symmetry, there is no reason why your starting shape has to have five sides. One of the reasons I adopted the non-absolute method of drawing the pentagon was that it made it easy to add extra sides to the polygon. For example, create a global variable:

```
    int _numSides = 8;
```

Now, change the **FractalRoot** class as shown in this listing.

```
class FractalRoot {
  PointObj[] pointArr = {};
  Branch rootBranch;

  FractalRoot(float startAngle) {
    float centX = width/2;
    float centY = height/2;
    float angleStep = 360.0f/_numSides;
    for (float i = 0; i<360; i+=angleStep) {
      float x = centX + (400 * cos(radians(startAngle + i)));
      float y = centY + (400 * sin(radians(startAngle + i)));
      pointArr = (PointObj[])append(pointArr, new PointObj(x, y));
    }
    rootBranch = new Branch(0, 0, pointArr);
  }

  void drawShape() {
    rootBranch.drawMe();
  }
}
```

Steps according to number of sides →

Now you have a structure capable of handling any number of sides. How about eight, as shown in figure 8.16?

Or 32? (See figure 8.17.)

Taking another approach, why should you feel limited to 360 degrees? I discovered that setting the angle step to 133 and stepping 8 times (effectively turning the circle three times) gave me something like figure 8.18.

I followed this line of exploration by making the angles and the number of sides vary according to a noise factor between frames, in the same way you varied the strut factor. You shouldn't have any difficulty working out the code if you want to try it. Through this process, I discovered what an incomplete revolution looks like (see figure 8.19).

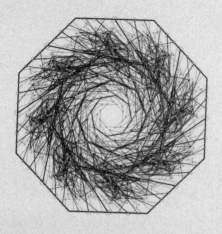

Figure 8.16

Eight sides: a Sutcliffe Octagon?

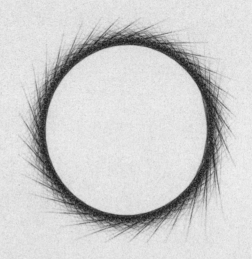

Figure 8.17

A 32-sided structure

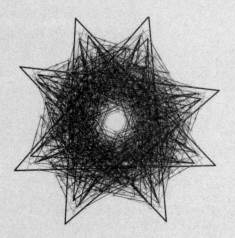

Figure 8.18

Angle step of 133, through 1024 degrees

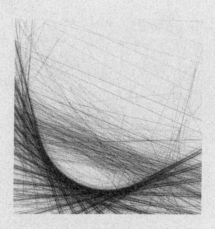

Figure 8.19

The system is resilient enough to work with irregular and incomplete shapes.

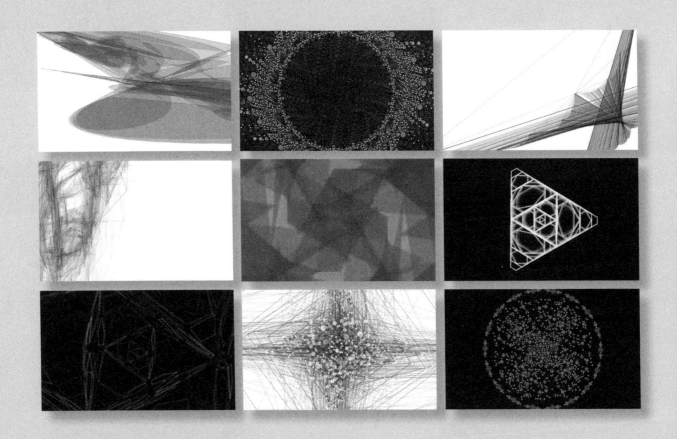

Figure 8.20
A number of abandonedart.org applications of the Sutcliffe Pentagon

The fractal structure I built (to Sutcliffe's specification) proved to be extremely mathematically sturdy, as long as I didn't turn the number of levels up too high. This meant I could wrench it about as if I were throttling a ferret, with the only consequence being that the results became less linear and more interesting.

I hope you're beginning to appreciate why this single fractal delighted me so when I started playing with it. Figure 8.20 shows a few of the ideas I've tried. You can find the code for all of these, along with the finished code for this section, at http://abandonedart.org.

This is where we leave fractals—and where we leave the book, too. If you can get your head around the code in this chapter, there really is nothing you can't conquer in Processing.

8.5 Summary

Fractals, another organizational structure we've stolen from the natural world, share a similar principle to the emergent structures we experimented with in earlier chapters. Simple code can produce complex results when magnified through reflexive recursion.

The main themes of this book have been unpredictability, emergent complexity, and fresh approaches to programming. In part 1, I introduced generative art, the Processing language and IDE, and the idea of allowing a certain artistic flourish into the strict discipline of programming. In part 2, our focus was on ways to force our computers into surprising us with unexpectedly sophisticated aesthetics, using random functions, noise functions, and mathematical constructions that produced results beyond what we can work out in our heads.

In this final part, the unpredictability we fostered arose from emergence; the interplay between large numbers of simple elements giving rise to levels of complexity beyond the competence of our humble programming skills. The manipulations of logic and procedure that we perform when creating generative art, no matter how abstract, clearly share principles with the more sophisticated computations of the natural world. Craig Reynold's *Boids* (chapter 6) performs a pretty good imitation of murmating starlings; two-state cellular automata produce patterns that are equally familiar to sociologists, biologists, and geologists (see figure 8.21 and chapter 7). Recursive fractal constructions are at their root an idea stolen from natural organization, as you've seen in this chapter.

Despite how it may look when viewed through a screen, we don't live in a digital world. Our reality is stubbornly analog: it doesn't fit into distinctly encodable states. It's an intricate, gnarly, and indefinite place. If we want to use digital tools to create art, which somehow has to reflect our crazy,

Figure 8.21
Patterns generated using the Vicniac Vote rule from chapter 7

chaotic existence, we need to allow imperfection and unpredictability into the equation. But, as I hope I've shown, there is room for the organic within the mechanical, and programming isn't just about efficiency and order. Our computing machines, which may only be capable of producing poor imitations of life, are tapping a computational universality that the natural world shares.

Programming generative art, if I were to try and sum up it up into a single pocket-sized nugget, is about *allowing the chaos in*. Not all things in life benefit from a structured approach; there is much that is better for a little chaotic drift. If you have a way of working that allows this freedom, permitting inspiration to buffet you from idea to idea, you'll inevitably end up in some interesting places.

Thanks for reading.

index

E

efficiency, in code, importance of **23**

ellipse function **18**

 drawing a circle with **67–68**

emergence **108–111**

 and complexity **125**

 and Complexity theory **108**

 and consciousness **111**

 ant colony as example of **108**

 as a way of generating organic artworks **111**

 as organizing principle **111**

 definition of **108**

 patterns in interactions **125**

 political connotations of **111**

 sociological perspective **110–111**

Emergence (John Holland) **108**

Emergence (Steven Johnson) **108**

emergent complexity **125, 128–144**

emergent networks **110**

endShape function **75**

Enlightenment **xxv**

Eno, Brian

 and generative music **7**

 Discreet Music **7**

F

fill

 introduction to **25**

 turning off **27**

fill function **75**

Final Cut Pro, usability **11**

Flash, usability **11**

flicker-fusion **45**

Flight Patterns (Aaron Koblin) **xxxiv, 150**

float **24**

flocking simulation, rule for **109**

Floyd, W. J., finite subdivision rules **171**

for loop **39–40, 54**

fractal

 and infinite recursion SEE *infinite recursion*

 case study, Sutcliffe Pentagons **170–187**

 angle step, varying **184**

 animating **181**

 constructing **171–180**

 description of **171**

 example **172**

 experimenting with **180–187**

 incomplete revolution **184**

 number of sides, varying **181**

 strut length, varying **180**

 exponential growth **165–170**

 introduction to **157**

 self-similarity, coding SEE *self-similarity, coding*

 space clockwork **165, 168**

 tree

 animating **163**

 beginnings of **162**

frame loop **27–30, 89**

 and noise **89**

frame rate, standards **45**

frameRate function **27**

Frosti (Matt Pearson) **xxvii, 102**

Fry, Benjamin **14**

 Visualizing Data **153**

function

 custom SEE *custom function*

 introduction to **18**

function block

 definition of **27**

G

Galanter, Philip, definition of generative art **3**

Game of Life **128, 134–137**

 and generative art **137**

 code **134**

 online examples **136**

 rules **134**

GarageBand, usability **11**

generative art

 aim of **xxxii**

 algorithms as tools to produce **9**